LEGENDARY LOCALS

OF

BEL AIR

MARYLA

D1290786

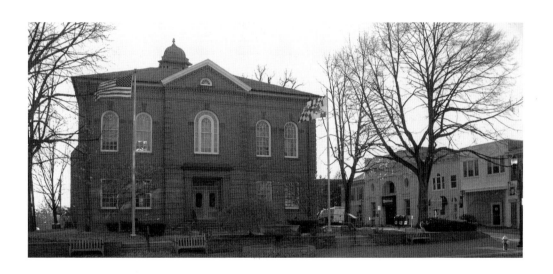

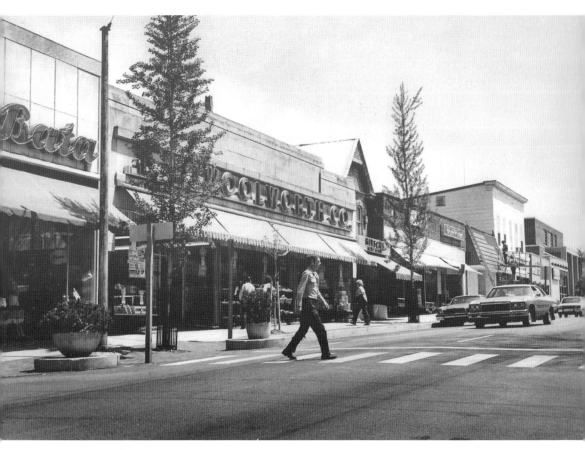

Bel Air's Main Street

For generations of residents, Bel Air's Main Street evokes memories of shopping excursions, parades, business deals, restaurant meals, romances, and friendships. (Todd Holden Collection, Harford Historical Society.)

Page 1: Harford County Courthouse

Harford County's original courthouse was erected around 1788. After a devastating fire in 1858, the current building was constructed and then expanded in 1904 and 1980. It has anchored the Town of Bel Air for over 150 years. (Kathi Santora.)

LEGENDARY LOCALS

OF

BEL AIR

MARYLAND

CAROL L. DEIBEL AND KATHI SANTORA

LEGENDARY
LOCALS

Legendary Locals is an imprint of Arcadia Publishing
Charleston, South Carolina

Printed in the United States of America

Library of Congress Control Number: 2015950827

For all general information, please contact Arcadia Publishing:
Telephone 843-853-2070
Fax 843-853-0044
E-mail sales@arcadiapublishing.com
For customer service and orders:
Toll-Free 1-888-313-2665

Visit us on the Internet at www.arcadiapublishing.com

Dedication
This book is dedicated to our legendary locals, those included here as well as the many others whose stories remain untold. They have made Bel Air a unique and welcoming community.

On the Front Cover: Clockwise from top left:
Lt. Gen. Milton A. Reckord (Harford Historical Society; see page 79), John Wilkes Booth, (Harford Historical Society; see page 119), Diane Lyn, radio personality (Kathi Santora; see page 76), Al Cesky, teacher and coach (Harford Historical Society; see pages 57, 110), Betsy the cow (Harford Historical Society; see page 22), Walter Holloway, volunteer fireman (Kathi Santora; see page 117), William Paca, politician (Harford Historical Society; see page 12), Kimmie Meissner, ice-skater (Kathi Santora; see page 111), Wendell Baxter, police officer (Kathi Santora; see page 101)

On the Back Cover: From left to right:
Warrenell "Boom Boom" Lester, boxing champion (Harford Historical Society; see page 105), Joseph Cassilly, states attorney (Kathi Santora; see page 56)

CONTENTS

ACKNOWLEDGMENTS

It has been an extraordinary privilege for us to assemble the photographs and write the stories for *Legendary Locals of Bel Air*.

Early on, Maryanna Skowronski, director of the Historical Society of Harford County (HSHC), lent her support and wide access to the society's records and photographs. Walt Holloway, HSCS volunteer extraordinaire, spent numerous hours searching the society's files, as well as his personal ones, to unearth just the right images. We consider him an honorary author of this book.

Jim Chrismer, a longtime HSHC volunteer and retired John Carroll School history teacher, shared leads, anecdotes, and records from his vast personal collection. Chuck Robbins, a recognized county historian and raconteur, helped guide our search for notable subjects and volunteered numerous hours in reviewing drafts for accuracy and entertainment value.

Chrita Paulin, administrator of the Historical Black Bel Air's Facebook page, shared memories of her childhood in Bel Air as well as leads to several family members of legends from the past.

Virtually every legendary local and family responded to our request to be included in the book with enthusiasm and grace. They trusted us with their stories, memories, and treasured family photographs. We have been touched by their confidence in us.

Both of us are longtime Bel Air residents and still learned countless new things about Bel Air and its people, past and present. If we were not able to include all details in the space of this book, we pledge to preserve what we learned in the most appropriate way so that future generations will remember Bel Air's unique place in history.

In all, the HSHC provided more than half of the photographs featured here. Unless otherwise noted, all photographs appear courtesy of HSHC. We are indebted to their generosity and commitment to preserving the past.

INTRODUCTION

*Harford County has always lain in the main stream of national life.
In a sense, its history is the record of our country, reduced in scale.*

—William S. James

People create the character of a place, determine its success or failure, and generate its personality. From its outset in colonial times, Bel Air's residents exhibited an ability to build an unusually cohesive community. Located in Harford County midway between Philadelphia and Annapolis, the town provided a natural gathering place in the early days of the country. The people of the past described here are a small sampling of the individuals who carved a thriving town out of a wilderness.

These individuals continually reinvented themselves and their community to meet an ever-changing world. Bel Air's central location made it an ideal county seat, but people like entrepreneur Thomas Hays and attorney Otho Scott built a town that became a desirable and respected place to live and work.

Businesses followed residential growth. At first, these were basic shops, inns, general stores, and blacksmiths. Over time, retailers located here and carried on the economic momentum that continues to form the community's foundation. Many of these businesses are multigenerational, like Klein's ShopRite, McComas Funeral Home, and Preston's Stationery. Others were groundbreaking for their day. These include J. Alexis Shriver's water, gas, and electric and telephone companies and the Ward brothers' engineering and construction firms.

Those that survived have one commonality, the ability to adjust with the times. The Mill of Bel Air, for example, started in the early 1800s as one of the major grain mills on the East Coast. As time passed, agricultural demands decreased, the railroad went defunct, and the business shifted as suburbanization changed the face of the community. It is to the credit of business owners like the Holloways that the Mill remains a highly successful enterprise after nearly 200 years.

With its designation as a county seat, the State of Maryland appointed commissioners and a sheriff to oversee county government. These regulators faced major challenges as they built a courthouse, jail, and almshouse. They oversaw the safety of area citizens and collected taxes. From the earliest days of the colony, many officials, most elected locally, served in Bel Air, Annapolis, and Washington.

With time and progress, leisure time increased. Artists, musicians, writers, and actors provided escape from everyday worries and entertainment for all. Bel Air is now a state-designated Arts and Entertainment District. Talented artists who call Bel Air home include Jim Butcher and Barbara Love, who have traveled the world honing their artistic skills. Mollee Kruger's writing talents have taken her to New York and beyond. Pianist Duke Thompson shares his musical gifts with Harford County students as well as international audiences.

Unfortunately, war played a large role in Bel Air's history. From its earliest days when local men gathered to form a militia to fight the British to the furiously split sympathies of the Civil War, local citizens played major roles in national events. When the Bel Air Armory was constructed in 1915 for the National Guard, it served as training ground for troops preparing for the Spanish-American War and, later, World War I. The American Red Cross and the Ladies Auxiliary assisted local soldiers by rolling bandages and providing many other support services. Lt. Gen. Milton A. Reckord, the armory's namesake, served a record 65 years in the military and left a lasting legacy.

These exceptional people owe a debt of gratitude to the ministers, educators, and professionals who guided them. These men and women led the youth to great heights, touched, and sometimes,

saved lives. One of these individuals, C. Milton Wright, is now known primarily for his history of the county, *Our Harford Heritage*. However, Wright started his career as a teacher. He then worked with juvenile offenders in a boys' home, became superintendent of schools, worked as the county's director of probation, chaired the Harford County Boy Scouts, taught in his church's Sunday school, and was treasurer of the county library.

Like the entertainers who so delight us, Bel Air's sports stars hold a very special place in the community. When Kimmie Meissner ice-skated in the 2006 Olympics, all of Harford County watched in amazement. She is just one of the athletes who brought the community together. Baseball, football, boxing, and especially, horse racing played a large role in Bel Air. Sports have created jobs, a sense of community, and lasting friendships.

The final chapter highlights the unique individuals who hold a special place in everyone's memory—some good some bad.

Each legendary local contributed to the character of the cherished place we call home. Please enjoy this journey from Bel Air's beginnings to the present day through its noteworthy people.

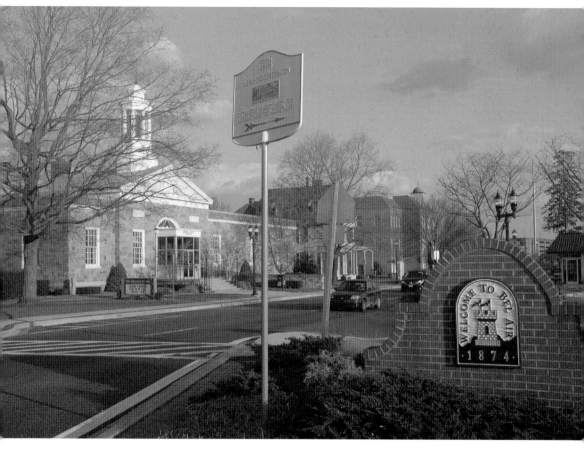

Historical Society of Harford County
The Historical Society of Harford County, situated at the site of the former Bel Air Post Office, is found in the northern end of downtown Bel Air. Volunteers donate hours of time to preserve the stories of Harford County's legendary people and places. (Kathi Santora.)

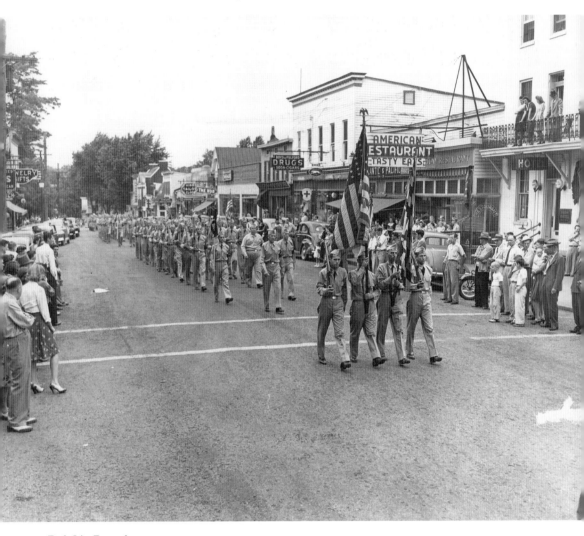

Bel Air Parade
Through the years, Bel Air's residents have displayed patriotism with parades, monuments, and ceremonies.

CHAPTER ONE

The Patriarchs and Founders

Aquila Scott carved Bel Air out of his depleted tobacco fields, laying out 42 lots between two streams and imaginatively naming this little village Scott's Old Fields. The timing and location could not have been more auspicious. Baltimore County was recently divided into two counties, and newly created Harford County needed a centrally located county seat, far from the malaria-ridden shoreline and convenient to water sources and well-established trails. To further encourage government officials to choose Scott's Old Fields as the county seat, Aquila deeded 2 5/8 acres to the new county in 1782 for a courthouse and prison. His son Daniel, who lived next to the proposed courthouse lot, was hired to survey the parcels. The deal was sealed with the provision that a new, more suitable name be found.

With a hometown located on the route from Baltimore to York and Philadelphia, early citizens routinely hosted dignitaries and traveled to Annapolis and Baltimore to conduct business. In a time when travel was strenuous and often treacherous, these early officials accomplished amazing feats locally, nationally, and internationally. William Pinkney served in various capacities under four presidents—Washington, Jefferson, Madison, and Monroe. Similarly, William Paca, another local statesman, made history as a signer of the Declaration of Independence and as governor of Maryland. Otho Scott, a legislator and attorney, is credited with the first codification of Maryland's laws and for his unique role during the Civil War as a representative to the Peace Commission of Maryland. Augustus Bradford served as Maryland's governor during the Civil War. These early officials established a pattern of service to the country and their fellow citizens, a commitment that numerous county residents continued through the years.

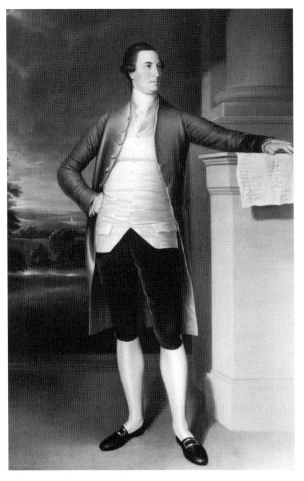

William Paca

A brilliant student and distinguished statesman, William Paca was born just east of Bel Air in Abingdon. He was the son of John Paca, a prominent planter with extensive landholdings throughout Harford County. After graduating with a master's degree from the College of Philadelphia in 1762, he attended Middle Temple in London to study law. Upon returning to Maryland, he studied law with Stephen Bordley, a prominent Annapolis attorney, passing the bar in 1764. He married Mary Chew, the daughter of a renowned planter, before going on to an illustrious career as a politician and judge.

Paca is most remembered as a signer of the Declaration of Independence, but as George Washington said of him, "Without him and others like him there would have been no United States." His political career began with his election to the Maryland legislature in 1771. From the beginning, he was in conflict with the provincial government. When the House refused to regulate tobacco without a fee reduction, the colonial governor issued a proclamation directing officers to charge fees according to the old law, thereby, infuriating local citizens. Paca and his fellow legislator Samuel Chase organized a procession though Annapolis, leading to a makeshift gallows. Meanwhile, other protesters fired guns from Paca's schooner in the harbor. The bill was hung from the gallows and placed in a coffin to send a message to the governor. Throughout this pre-Revolutionary period, Paca was an integral part of the protests against the British using the courts and swaying public opinion through his many published articles.

In 1774, Paca was appointed to the First Continental Congress and, later, helped develop Maryland's First Constitution. Following the adoption of the Constitution, he was appointed to a two-year term in the US Senate. In 1778, he was appointed chief judge of the Supreme Court of Maryland. In 1782, he was elected for the first of three consecutive one-year terms as governor. Representing Harford County as an Anti-Federalist in the Ratification Convention of 1788, Paca proposed 28 amendments that mirrored the safeguards in the Maryland Constitution. Although these were not immediately adopted, several of his ideas formed the basis for the subsequent passage of the Bill of Rights. Following this, Paca was appointed as chief judge of the US Court for Maryland in 1789, a position he held until his death in 1799.

William Pinkney

William Pinkney, considered one of the most talented lawyers, statesmen, and orators of his time, was born in Annapolis in 1764. He pursued classical studies and medicine but never practiced. He then went on to study law with Samuel Chase. After passing the bar in 1786, Pinkney moved to Bel Air where he started his law practice and married Harford County native Anna Maria Rodgers, the daughter of Col. John Rodgers. His career soon pulled him back to Annapolis, and he represented Harford County in the Maryland House of Delegates from 1788 to 1792. He was a member of the Maryland Convention that ratified the Constitution in 1788. Like his fellow Harford County representative, William Paca, he voted against ratification.

By 1796, Pinkney's talents became widely valued, and he was chosen by George Washington as one of the commissioners to London under the Jay Treaty. There, he attempted to settle the claims of US merchants against the British government for maritime losses during the Revolutionary War. He also successfully settled a claim for the State of Maryland against the Bank of England.

On returning to Maryland in 1805, he became the state's attorney general, a position he held until 1806. At that time, Pres. Thomas Jefferson sent him back to the United Kingdom as minister to the court of St. James to negotiate reparations and to contest the impressment of US soldiers. In 1811, he was called back to the states to serve as US attorney general under Pres. James Madison. Shortly thereafter, the War of 1812 intervened. Pinkney joined the forces serving as a major in the Maryland Militia, sustaining a serious wound in the Battle of Bladensburg.

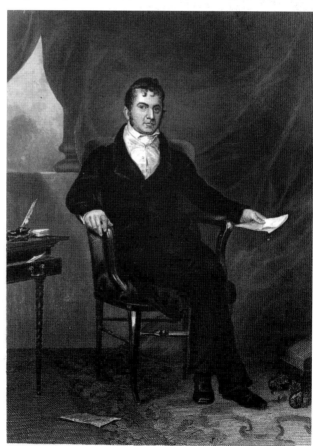

In 1814, he was elected to the 14th US Congress, serving until April 1816, when he resigned to accept the position of minister plenipotentiary to Russia, with a special mission to Naples. Five years later, at the death of Sen. Alexander Contee Hanson, Pinkney was elected to the US Senate, where he served until his death in 1822.

Throughout these many years of service, Pinkney also maintained his law practice, successfully arguing many important cases before the Supreme Court including McCulloch v. Maryland (1819) in which the power of Congress to charter the Bank of the United States was upheld.

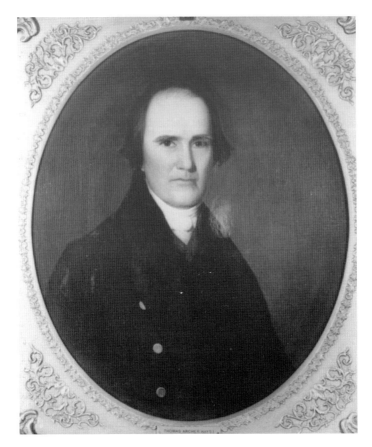

Thomas Archer Hays

Thomas Hays, a leading 19th-century Bel Air citizen, left a lasting legacy. He was a successful attorney, farmer, real estate speculator, shopkeeper, and landlord, owning 15 of the 42 lots in Bel Air and more than 4,000 acres throughout the county. His holdings included the Union Tavern, the Granger Hotel, a blacksmith shop, several stores, and a kiln. In a time before banks, he also offered a mortgage service.

Hays provided land on Pennsylvania Avenue for the First Presbyterian Church and the Bel Air Academy, as well as land on Main Street for the Methodist church. The Bel Air Academy, a private boys school, was incorporated in 1811 but did not open until 1814, when Hays advanced funding that allowed school construction to proceed. Meanwhile, he provided space in an unfinished still he was constructing on Church Street (now Pennsylvania Avenue) so classes could begin. Eventually, the land was transferred to the school where the academy building still stands.

In 1808, Gov. Edward Lloyd appointed him the quartermaster for the 40th Maryland Military Regiment, a regiment later called up to fight in the defense of Baltimore in 1814. This was the beginning of a series of notable gubernatorial appointments, including commissioner for building streets and boundaries of Bel Air and commissioner for the building of fireproof offices.

When the state issued a charter for the construction of the Baltimore and Harford Turnpike Company in 1816, Thomas Hays and James Steel became the company's first managers. Starting with capital of $60,000 divided into $50 shares, the road was laid out between Baltimore, Bel Air, and Conowingo. To assure that the road would pass his own Union Hotel at Main Street and what is now Baltimore Pike, he offered to purchase a substantial amount of stock, thus fixing the location of today's Route 1. In 1846, the town paved Main Street as new turnpike traffic drew more activity to the area. The town held a lottery to raise funds and appointed Hays to manage construction. The project took 129,000 bricks, many of which came from Thomas Hays's kilns.

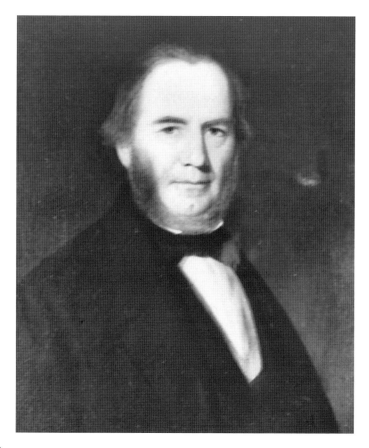

Otho Scott

Otho Scott, the grandson of Bel Air's founder, Aquila Scott, was born in 1795. He served in the militia in the War of 1812 before reading law with Israel Maulsby in Bel Air. Admitted to the bar on March 13, 1821, he immediately entered into a career of success and distinction both at his home circuit and the Court of Appeals. Scott represented clients who ranged from local widows to major railroads. By his third year, he appeared in a third of all county trials. In the Chancery dockets, he represented one side or the other in more than half of all cases from 1821 to 1845. He represented the Delaware & Maryland Railroad Company in proceedings regarding condemnation resulting in a legal opinion used not only in Maryland but in several other states. He also is credited with training in the law Augustus Bradford, Maryland's Civil War governor, and Henry Farnandis, a well-known state senator.

Scott's legal legacy was exceptional, but his personal achievements were equally outstanding. Recognizing a need for a fireproof building in which to store his extensive library, he designed and built the first fireproof building in the state. He built the stone structure on Main Street opposite the Harford County Courthouse. Before trusting his cherished library to the building, however, he tested the structure by piling several cords of wood in the building, setting it on fire just to make sure it was truly fireproof. The stone building passed the test with only minor damage and stood next to the old jailhouse lot well into the 20th century.

Scott served several terms as a state senator and was hired to codify the state laws of Maryland (the Code of 1860). He condensed two volumes of varied and unskillfully framed laws dating back to the state's foundation. The effort was applauded as the "best ever produced" by eminent historian Walter Preston. During the Civil War, Scott was appointed as a member of the Peace Commission of Maryland. The commission met with President Lincoln on May 7, 1861, and presented a resolution declaring Maryland's support of the Union in an attempt to forestall any military occupation of the state.

Augustus Williamson Bradford

Augustus Bradford was born at his parents' home on Main Street. He studied law under Otho Scott, a local attorney, and was admitted to the bar in 1826. He soon moved to Baltimore, where he met his wife, Elizabeth Kell, with whom he had 12 children.

He served as clerk of the court in Baltimore County and, later, on the Washington Peace Conference. He so impressed members of the Union Party during his Conference speech that he was selected as their candidate for governor.

His tenure as governor was grueling with both political and personal tragedies throughout the war years. In 1864, Bradley Johnson's raiders attacked Bradford's home in Baltimore, burning it to the ground along with all of his possessions, his library, and papers. Luckily, no one was hurt in the incident. A park now stands on Main Street as a memorial to Governor Bradford.

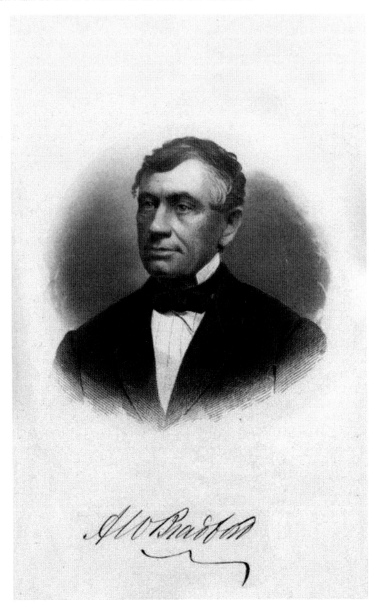

CHAPTER TWO

The Agrarian Beginnings

Like most British colonial areas, Bel Air began as a farming community of several land grants from the Crown. The Scott family grants dated to the early 1600s and incorporated the 42 lots that eventually would become the town along with thousands of acres along the surrounding stream valleys. Their holdings included the land that now houses town hall, the Bel Air Volunteer Fire Company, the Shamrock Park neighborhood, Bel Air Memorial Gardens, Winters Run Golf Club, and surrounding areas.

Once established as the county seat, Bel Air officials initiated construction of a courthouse, jail, and almshouse (home for the destitute), as required by state law. Houses and shops soon followed, lining Main and Bond Streets. This central core provided support services for surrounding farms and incoming travelers. Initially, farms completely surrounded the five blocks that made up the official town boundaries, but these were soon carved into smaller, more manageable units.

The land along what is now Hickory Avenue served as the site of the county almshouse where the poor were sent to live and work on the farm. Later, it was home to Rev. Reuben Davis, the principal of the Bel Air Academy. Eventually, the property was divided and sold to the Archer and Dallam families, who expanded the properties and farmed them. Farther north on Hickory Avenue, the McCormick family owned Majors Choice, another significant land grant. This property, originally owned by Bernard Preston, led to Moores Mill, a grain mill once operated by James Scott before being purchased and expanded by James Moores, who also incorporated William Paca's property, Southampton, into his holdings at Moores Mill. William, Joshua, and Buckler Bond's lands stretched from Bond Street to what is now Fallston. The Durham farms bordered the area along Route 1, near Tollgate Road.

World events continually impacted Bel Air's farming community, its size, style, and ownership. Early settlers were primarily European immigrants, who mainly focused on tobacco, the cash crop of the time. However, these farmers were soon forced to adapt to new crops as tobacco quickly destroyed the soil. Later in the early 20th century, the fertile soils surrounding the town brought a new group of immigrants, the "Down Yonders." These were families forced out of Appalachia as that economy collapsed during the Great Depression. Farmers such as Felix Irwin and Orley Reedy not only survived this move, but truly thrived, bringing new life into the community.

Several of these family farm holdings remained intact well into the 20th century and shaped the community that is today's Bel Air.

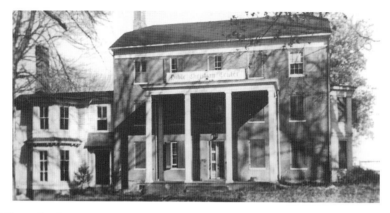

Henry Wilson Archer

Henry W. Archer purchased the Shamrock mansion off of Churchville Road in 1850 shortly before his marriage to Mary Elizabeth Walker, a Kent County girl who would oversee major modifications to the property and bear nine children. The 65-acre farm already had a history, having been the first county almshouse and the home of the principal of the Bel Air Academy, Rev. Reuben Davis.

The property, known locally as Archer's Hill, included a 19-room mansion, slave quarters, and farm buildings. Several generations of the Archer family lived on the property, which was the center of much of the community's social life. The Archers were prominent lawyers, doctors, and noted secessionists during the Civil War. After the war, Henry Archer went on to become a member of the Maryland Constitutional Convention in 1867.

The Archer family held the property until 1955, when it was sold to the Sparr Construction Company. Sparr built the housing development currently known as Shamrock Park and deeded the town the land that now houses the Bel Air Town Hall, the Bel Air branch of the Harford County Library, and Shamrock Park.

To make room for additional lots, in 1963, Sparr arranged to have the fire department conduct a controlled burn. Seventy firemen and ten fire trucks set various types of fires and extinguished them until the Shamrock homestead was leveled. One of Bel Air's most historic and architecturally important residences was lost forever.

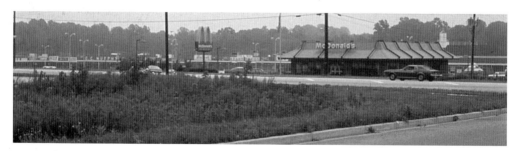

Jacob Gladden Durham

Jacob G. Durham purchased his farm on Baltimore Pike from the Boarman family in 1922. At his death in 1946, the farm went to heirs, who eventually sold a 44-acre portion of the property to Grove Point, Inc., a family corporation specializing in shopping center development. The Julio family, owners of the corporation, requested annexation of the property into the town limits, allowing them to connect to the town's sewer system and to obtain commercial zoning necessary to build the county's first strip shopping center, Bel Air Plaza.

In March 1963, seven months after the annexation's approval, several local business owners filed an appeal seeking to overturn the decision, fearing the development's impact on local businesses. The court upheld annexation approval and thus began the commercialization of Baltimore Pike.

Felix Mack Irwin

Part of the North Carolina migration, Felix and his wife, Maye, moved to their farm at Moores Mill Road and Hickory Avenue in 1919. As automobile travel became more popular, the farm's location on Route 1 became a natural stopping point for motorists looking for a place to camp overnight during the trek between New York and Florida.

The Irwins recognized the business opportunity by providing cabins and campsites. By 1923, the corner of the farm included Del Haven, reputed to be the first East Coast motel/restaurant complex. They advertised "modern steam-heated rooms, private baths, Beautyrest mattresses, running water and a community kitchen." The adjoining swimming pool was surrounded by stone walls, paths, and bridges over a stream. Benches allowed travelers to take in the country air. In spring and summer, the hotel hosted dances on the roof. The pool was available to area residents, and a recently discovered logbook reveals the names of many local icons who cooled off there. (Felix and Marcia Irwin.)

DEL HAVEN HOTEL AND CABINS

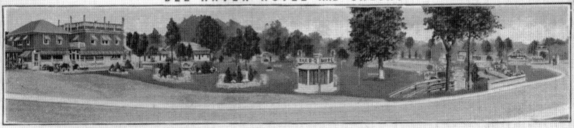

NORTH SIDE BELAIR, MARYLAND — ON ROUTE 1 3A100

19

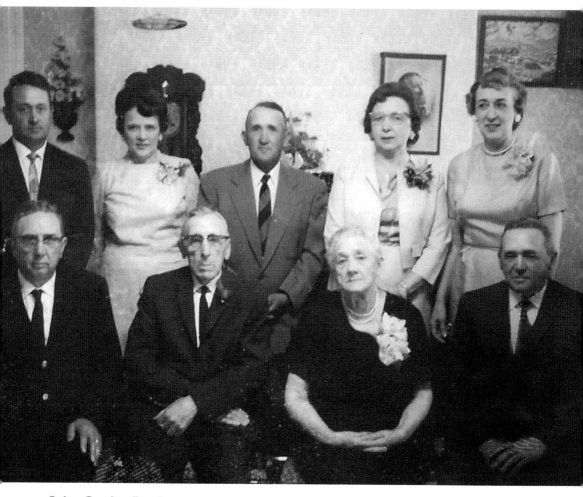

Orley Gordon Reedy

In the early years of the Great Depression, a slow migration brought Appalachian families to Harford County from the hills of North Carolina and West Virginia to escape mounting poverty and to seek the promise of fertile land and employment. Orley Reedy was one of these migrants. A former teacher in Ashe County, North Carolina, he and his wife, Dora, purchased a 132-acre parcel on Hickory Avenue from Lawrence McCormick. It was part of James Maxwell's original Majors Choice land grant.

The Reedys and their seven children worked diligently to rebuild and expand the decaying homestead. They gave farmhands board and a salary of $10 a month. Orley Reedy purchased cows, chickens, turkeys, hogs, horses, and mules to get the operation moving. Money was scarce. Most local banks had closed as the Depression dragged on. Work had to be done with horses and mules since mechanized equipment was almost nonexistent. Soon, Mr. Reedy was shipping milk and chickens to the Baltimore market via the Maryland & Pennsylvania Railroad, known locally as the Ma and Pa, and trucking live turkeys to Washington, DC, for sale at local markets. The Reedy farm eventually became one of the most productive farms in Harford County. Typically humble when asked his occupation, Reedy stated that he was a "dirt farmer."

After Orley Reedy's death, the property was sold for development and is now Major's Choice, a 450-plus-unit residential neighborhood that forms the northwestern border of the Town of Bel Air. (Doris Grafton.)

Adelaide Newcomer Noyes

Adelaide Noyes's life seemed at times a series of contradictions. Reportedly a shy girl, she made her social debut at the 1923 Bachelors' Cotillion in Baltimore, volunteered in hospitals, attended country club parties, and enjoyed horseback riding. In 1927, she married Victor Noyes, a Naval Academy football star and horse breeder, and moved to an estate in Long Green Valley. There, she and Victor raised and trained Thoroughbreds. In the early 1930s, Adelaide Noyes earned a pilot's license and flew her own plane.

Just before World War II, the family moved to Hazel Dell on Vale Road on the outskirts of Bel Air. Adelaide Noyes held very strong pacifist views and was an ardent believer in nonviolence. Along with a few other local peace advocates, Noyes joined the Women's International League for Peace and Freedom, an organization dedicated to establishing the political, economic, social, and psychological conditions that would assure peace and freedom in the world. She joined the Quakers and dedicated her life to antiwar causes starting with World War II through the Vietnam War. She marched in demonstrations at the Pentagon, protested against chemical warfare research outside Edgewood Arsenal, and was an enthusiastic supporter of world government.

In the 1950s, she hosted a buffet supper for a racially diverse group of friends. Someone reported the gathering to the FBI, and by the next morning federal agents were asking her husband about her activities. In 1965, she went to Selma, Alabama, to help register African American voters, continuing her efforts to foster better relations between blacks and whites even at considerable risk to herself.

Noyes cared for everyone. She routinely shared the farm with her neighbors. Local children played Little League baseball games on the Hazel Dell fields. The family sponsored horse shows there and provided the fields as a haven for peace marchers throughout the 1960s. Recognizing her belief in peace and racial equality, her family and friends established the Adelaide Newcomer Noyes Peace Fund for peace studies and activities at Johns Hopkins University. (Charlotte Washburn.)

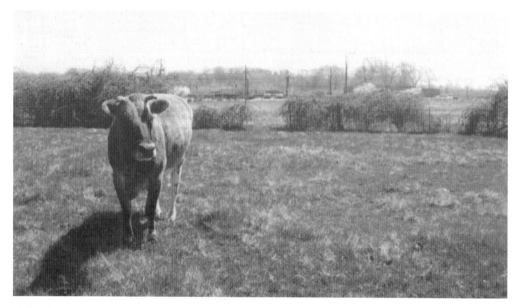

Betsy, the Cow

Betsy, a Jersey cow, saw much "progress" from Glen Deaton's farm pasture (now Bel Air Town Center). At her birth, the farm lay adjacent to the Bel Air Racetrack and the relatively new Howard Park subdivision, formerly Kelly's Orchard, which had been situated on the Liriodendron property. Soon Betsy's next-door neighbor became Harford Mall, the first shopping mall in Harford County. For years, Betsy served as an icon for county residents, reminding them of Bel Air's agrarian past. With Glen Deaton's death in 1988, the property was sold to become the Bel Air Town Center, and Betsy was put to pasture on a nearby farm.

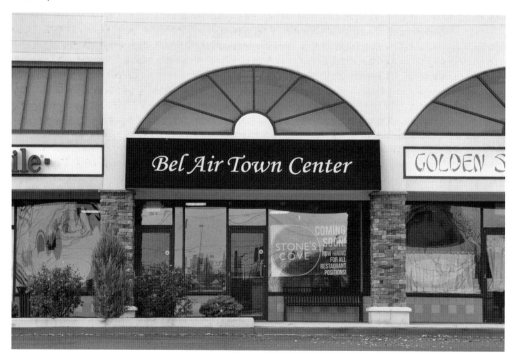

CHAPTER THREE

The Economic Engines

From its inception, Bel Air was the economic center for the surrounding farm community and a haven for travelers. Initially, the business community consisted of a few stores, government buildings, inns, taverns, blacksmiths, and a mill. With the expansion of the canning industry after the Civil War and the introduction of the Maryland & Pennsylvania Railroad, the community bustled. Canners needed factors, or brokers, to sell their products, a central shipping point for supplies, workers, and a convenient location to shop. People like industrialist Alexis Shriver, retailers Solomon and Mary Getz, and insurance pioneer George Cairnes found their niche.

The government center was home to attorneys who assisted entrepreneurs and helped establish local banks. The first, Harford National Bank, opened in 1881. The courts and government offices attracted visitors as did the Bel Air Racetrack, the most popular venue in town. People came from all along the East Coast for races, stayed in local inns and supported area shops. The canneries brought recent immigrants who worked on nearby farms during local harvests. City dwellers retreated to newly built Victorian boardinghouses that lined Main Street for a respite from summer heat.

The 1900s brought ever more dramatic changes, with the introduction of the automobile and increased leisure time. New businesses appeared, and old ones were modified. With ever-changing modes of transportation, technology and outside influences of suburbanization, fashion, and progress, the small-town atmosphere of Bel Air and its traditional economic underpinnings faced serious threats. These required businesses to constantly reinvent themselves. Shopping centers replaced the racetrack and area farms. The inns of earlier days disappeared. Offices and engineering and technology firms took over the old retail areas. Yet, the town managed to retain a distinctive character, much to the credit of its merchants, including the Kunkels, Prestons, Buontempos, and many others.

Today, Business Route 1 resembles much of small-town America with shopping centers and auto-related businesses. Main Street retains a large measure of its original charm and even a few original businesses like the Mill and Boyd and Fulford drugstore. This chapter traces the personal stories of the people who built Bel Air's financial, banking, and legal district; its railroad industries; and retail corridors. Each century added new dimensions to the community, addressing ever-changing needs, desires, threats, and opportunities. Still, people and families remain the real story—the reason this community retains its unique charm.

J. Alexis Shriver

Born into a wealthy, well-known Baltimore family, Shriver attended Cornell University, graduating in the early 1890s. He then moved to Olney, a 264-acre farm outside of Bel Air on Old Joppa Road, and began an illustrious and multifaceted career. Recognizing the possibilities of the new invention, the telephone, Shriver started the Bel Air Telephone Company in the late 1890s, overcoming the reticence of town fathers who initially refused to allow telephone poles for aesthetic reasons. He eventually sold the firm to the C&P Telephone Company. His interest in technology led him to found Bel Air's first electric company and to develop a municipal water company. These ventures proved highly successful and only increased Shriver's thirst for new scientific adventures. Owning a major working farm, Shriver knew well the many issues that faced rural property owners and began researching and writing pamphlets for the US Commerce Department on a variety of agricultural subjects.

A true Renaissance man, Shriver delighted in history and architecture. Initially, the 200-year-old home at Olney consisted of numerous simple buildings, many constructed by his Quaker ancestors. He added many outstanding architectural elements to his home from several early-20th-century Baltimore city dwellings slated for demolition. These included delicate pieces of woodwork from the Van Bibber house in Baltimore's Fells Point, marble panels designed by L'Enfant, and monumental Ionic marble columns from the Baltimore Athenaeum.

This love of history extended even beyond his home. He wrote the books *Washington's Trips Through Maryland* and *Lafayette in Harford County* and numerous articles on historic county figures. He is credited with sustaining the Historical Society of Harford County and generating membership and enthusiastic support of the society's mission. Under his leadership, Harford County was the first to take part in the Maryland Roadside Historical Marker Program.

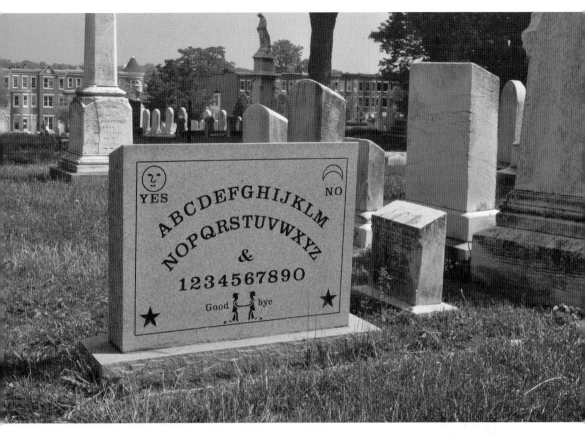

Elijah J. Bond

Best known for patenting the Ouija board in the United States and Canada, Elijah Jefferson Bond was the fourth child of Judge William Bond and Charlotte Howard Richardson. Elijah and his two brothers, Frank and Arthur, served in the Confederate army during the Civil War. In 1872, Elijah graduated from University of Maryland School of Law and opened a law practice in Baltimore. While at the university, he became close friends with Harry Welles Rusk, a fellow student who went on to become president of Kennard Novelty Company in 1890.

Though not officially a member of the Kennard Novelty Company, Bond registered and assigned the original Ouija patent on February 10, 1891, to William H.A. Maupin and Charles Kennard. The Canadian patent was filed in March 1891. Shortly after that, Bond reached an agreement with International Novelty Company granting them sole right to this patent and therefore the ability to manufacture Ouija boards in Canada.

Elijah Bond died on April 14, 1921, and was buried in an unmarked grave in Baltimore's Green Mount Cemetery. In 2007, Ouija board historian and expert Robert Murch located the grave and worked tirelessly with the cemetery to install an appropriate marker. After obtaining permission from surviving family members, Baltimore's Tegeler Monument Company designed a monument reminiscent of a Ouija board. Fans of the game can pay their respects to the man who first patented a favorite piece of Americana. (Kathi Santora.)

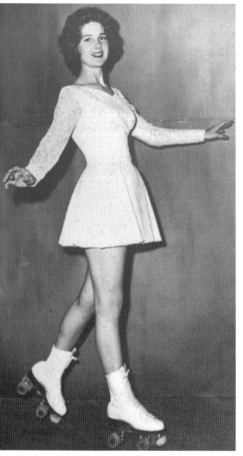

Carole DeRan

Born in White Hall near Ayres Chapel, Carole DeRan spent her early years on the family farm at Black Horse, later moving with her mother and stepfather, Joseph Orr, to the grocery and feed store they owned in Highland. In 1950, her parents moved to Hickory to pursue Joseph's dream of building a roller rink. Such a venture was quite uncommon at the time. Only one other roller rink existed in the Baltimore area. Orr modeled the Bel Air roller rink on one he had seen in Ohio and used surplus materials from Aberdeen Proving Ground (APG) and the labor of friends and family. Friends Marshall Scarboro, Donald Dick, and Orr developed the design of the open-span structure.

Initially, the floor was Masonite with a blue plastic coating developed at APG. Six years later, they added a maple floor. As children, DeRan and her stepbrothers and sister helped lay the floor. They also rented skates, cleaned, took tickets, and demonstrated skating techniques. She performed in speed skating and dance skating contests, representing the county in national competitions in Nebraska and Texas. DeRan always insisted that her brother Sam was the better skater. Besides skating lessons, the rink sponsored Buddy Dean record hops and costumed Halloween parties. Buses regularly brought teens from the Parkville area to Bel Air on Friday nights.

The family opened additional rinks in Virginia and North Carolina. After college graduation, DeRan started a 30-year career as a Harford County social studies teacher. The rink was eventually sold and is now a shopping center whose design recalls this beloved landmark. (Carol DeRan.)

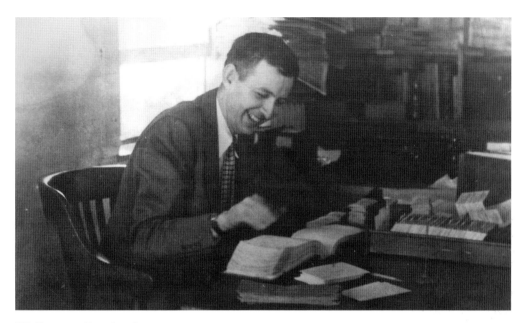

W. Eugene Graybeal

W. Eugene "Gene" Graybeal was a Main Street fixture, where he and partner Horace Boarman operated Courtland Hardware. A graduate of the University of Baltimore Law School, Graybeal never practiced law. He found his true callings elsewhere, first as an instrument flight instructor for the Civil Air Patrol in the 1940s and then as a pilot for Chicago and Southern Airlines (now Delta Airlines). Finally, from 1950 to 1981, he was co-owner of Courtland Hardware, earlier founded by Bond Boarman in 1918 on the southeast corner of Main and Courtland Streets. The store is still in operation at 6 North Bond Street and is operated by former employees Jim Kunkel and Richard Thomas, who have expanded to several additional locations. The original building, which had portions dating back to 1814, was demolished in the mid-1980s. (Graybeal family.)

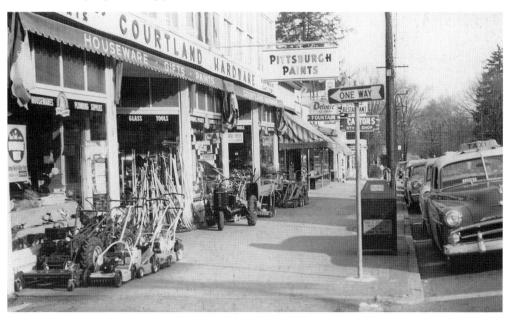

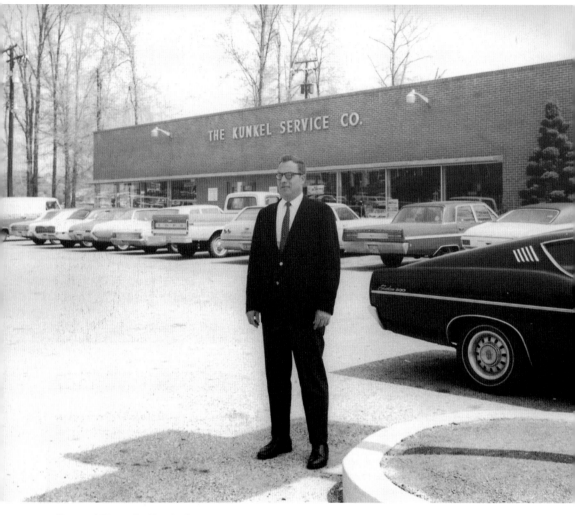

Gerard Francis Kunkel

John and Dora Kunkel moved to Bel Air with their newborn son Gerard in 1925 to be closer to the family's Bel Air Store, Kunkel's Auto Parts. Kunkel's great-grandfather started the family business as a wheelwright and carriage shop known as Monumental Wagon Works in Baltimore City in 1864, just nine years after immigrating to America from Germany. As horse-drawn vehicles declined in use, Gerard's grandfather Frederick Kunkel modified the company's product, building truck bodies and selling Goodyear tires. The tire franchise proved very lucrative, allowing for expansion into Norfolk, Virginia, and at home in Bel Air.

Kunkel studied at Georgetown Preparatory School and then attended Massachusetts Institute of Technology (MIT) in 1942 with dreams of becoming an aeronautical engineer. Two years into his degree, he was drafted and sent to Los Alamos to work on the Manhattan Project. He assisted with development of an explosive mechanism that would compress the bomb that would eventually be used against Japan. After his years of service, Gerard returned home and completed his degree at MIT and was offered a position as an aeronautical engineer in Texas. However, as the only son, his father needed him to help with the business. He remained in Bel Air and managed Kunkel's Auto Parts for the next 48 years, expanding it from 4 to 15 stores. (Sarah Kunkel Filkins.)

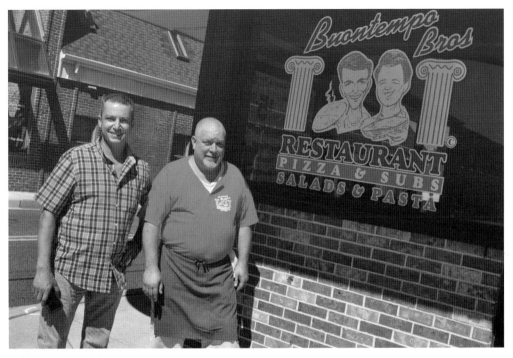

Renato Buontempo

Renato Buontempo has served up many pizzas and pasta dishes in several large East Coast cities. However, when he arrived in Bel Air to join family already living in the area, he knew there was something he liked. Main Street reminded him of his hometown, Monte di Procida, Napoli.

Since 1989, Buontempo Brothers has been a landmark eating destination. His brother was his original business partner. When Renato's brother returned to Italy, he asked longtime employee Richard Lynch to become his business partner and co-owner.

Renato's interest in Main Street grew, and he began looking to invest in this community that he had made his own. Knowing this, town officials approached him in 2002 when the Red Fox Restaurant closed for a second time. The restaurant, a block south of Buontempo Brothers, had served Bel Air since 1954. It was the regular eating and meeting place for the town's professionals, the site of many political deals, and the center of social events. After its closure in 1998, the void was visible. Its size and condition frightened off potential buyers. Renato agreed to take on the challenge, creating one of the most popular eating establishments on Main Street today, the Tower Restaurant.

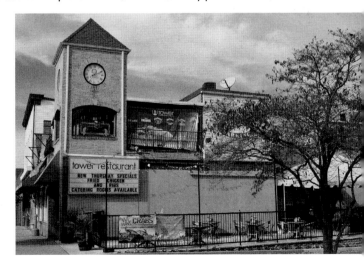

Renato is equally committed to community causes. He has responded to many of those in need, including providing space for fundraisers for children and lending a hand with the Bel Air, Maryland, Main Street Program. (Kathi Santora.)

Frederick and R. Walter Ward

Few people have had more impact on Bel Air than the Ward brothers. The Ward family moved to the area from Appalachia during the Depression, following many other farming families to Maryland in search of a better life. Life was not easy. The family worked on several area farms as tenant farmers and eventually shifted to carpentry. Fred and his mother contracted tuberculosis and were hospitalized in the late 1930s. Mrs. Ward did not survive. Still the work ethic in both brothers, Frederick and R. Walter, remained strong.

In 1945, after graduating from Bel Air High School, Fred joined the military and served in the Pacific. On returning home, he used the GI Bill to become the first person in his family to graduate from college. Finishing second in his class at the University of Maryland with a degree in civil engineering, he returned to Bel Air and opened a land surveying company. Most local engineers started their careers surveying with this company, now known as FWA, Inc.

By the mid-1970s, Bel Air's Main Street was suffering from the exodus of businesses to Route 1 shopping centers. Fred Ward became a prominent leader in salvaging the historic Main Street community, renovating old retail buildings and taking a chance on downtown when no one else would. The success of his efforts can be seen in today's thriving downtown.

R. Walter Ward also left his mark on the town. At the age of 21 or 22, he became the youngest real estate broker in the state, opening his first office in his parents' home at 306 Thomas Street. He entered into a partnership with longtime friend Melvin Bosley. Together they changed the face of the county forever.

Their first project was Howard Park, built on the former Liriodendron orchard. In the aftermath of World War II, there was a tremendous housing deficit. Ward and Bosley filled this void by building affordable houses in a subdivision, a new concept at the time. Houses sold quickly, and soon the partners purchased farms all along South Main Street (Emmorton Road). As the county extended public utilities, they built ever more new subdivisions that extended from Bel Air to Edgewood.

These brothers left a lasting legacy and created much of the image of today's Bel Air. (Ward family.)

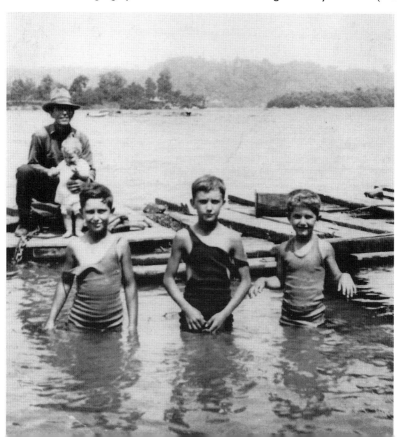

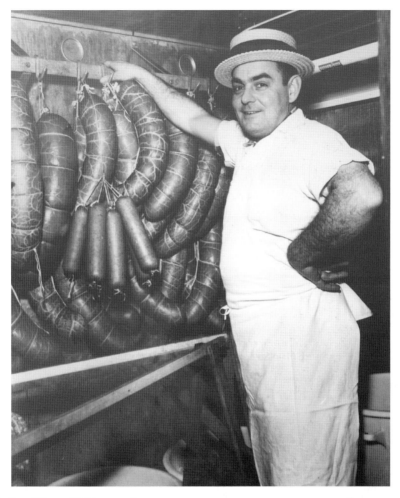

Joseph Julius "Peppi" Simmeth

Peppi's Meat Market drew customers from as far away as New York, Virginia, and Washington, DC. Its owner Joseph Simmeth prepared, smoked, and cut meats on site according to family recipes that dated back as far as 300 years.

Peppi was born in Passau, Germany. He worked in the family's butcher shop from an early age. When World War II began, he was 17, old enough to join the Army. Three years later during the siege of Stalingrad, Peppi, as one of only nine survivors in his division, was taken prisoner by the Russian army and sent to Siberia. After six years of forced labor in the Ural Mountains asbestos mines, he was released and returned home.

He did a stint in the early 1950s at a US meatpacking house but returned home after about six months. After his wedding and the birth of his first child, he and his family immigrated to the United States permanently. Initially, he worked as a bologna maker in the Bronx but found the city too hectic. His sister lived in Bel Air. The rural atmosphere reminded him of his village in Bavaria. He found a job with Benson's Meat Market and moved the family to their new home. Two years later in 1961, Peppi and his wife opened a meat market on Hays Street using borrowed equipment from his former employer in the Bronx. Word soon spread about the quality and conviviality of this new store and its owners. Before long, the store became a community fixture. Peppi retired in 1988, passing on the business to longtime employee David Moser. When Moser retired in 2006, the store was demolished. The vacant lot is now owned by Harford County.

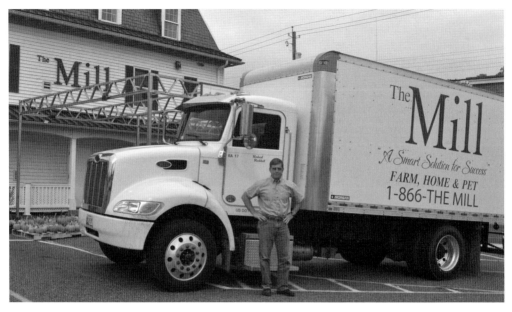

Henry Holloway

It is a challenge to own a farm supply store in the middle of suburbia. Henry Holloway, the current owner of the Mill of Bel Air, made it work.

Holloway's grandfather H. Smith Walter purchased the former Reckord Mill at 424 North Main Street and opened it as a farm supply store in the early 1950s, so that he could also access the adjacent Maryland & Pennsylvania Railroad for his Forest Hill–based business, Walters Feed Mill. The business thrived since most of Harford County was dotted with farms and fields. Just three years later, though, the railroad shut down.

When Walter retired, his grandson Henry Holloway took over the business, renaming it the Mill of Bel Air. Holloway adapted the business as Harford's landscape changed. Today, six locations serve the county's agricultural and equine community as well as its home gardeners, hobby farmers, bird lovers, and pet owners.

Holloway credits his staff with his success and says, "If you know your product and how to take care of an animal, bird or plant, then you can get good information to your customer. It doesn't make any difference if the customer has a 5,000-square-foot lawn or a 5,000-acre farm." (Kathi Santora.)

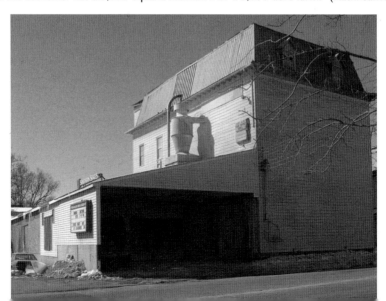

John D. Worthington IV

In 1856, John Carroll Walsh and John Cox founded the *Southern Aegis* and *Harford County Intelligencer*, a four-page newspaper with strong Confederate sympathies. Ownership and the publication's name changed several times before the newspaper, located at 119 South Main Street, was purchased by John D. Worthington Sr. in 1904. The following year, the expanding publication, now known simply as the *Aegis*, moved to 29 Courtland Street. The paper's name is still visible on the facade of this historic building. Expanding with each successive Worthington generation, the offices moved to Hays Street in 1963, eventually encompassing an entire block and containing state-of-the-art presses and the WVOB in Bel Air radio station.

In 1973, John D. Worthington IV took his place at the *Aegis* as the fourth generation of Worthingtons. He began as a reporter. After five years, he worked his way to management and is credited with overseeing the newspaper's publication when it was voted Newspaper of the Year by the Maryland/Delaware Press Association in 2001 and again in 2008. The *Aegis* was purchased by Times Mirror, owners of the *Baltimore Sun*, in 1986 and then by the Tribune Company in 2000. John D. Worthington IV remained the publisher and vice president until his retirement in 2010, a career spanning 37 years and one that brought to a close the Worthingtons' 105-year dynasty as publishers of one of the county's premier newspapers.

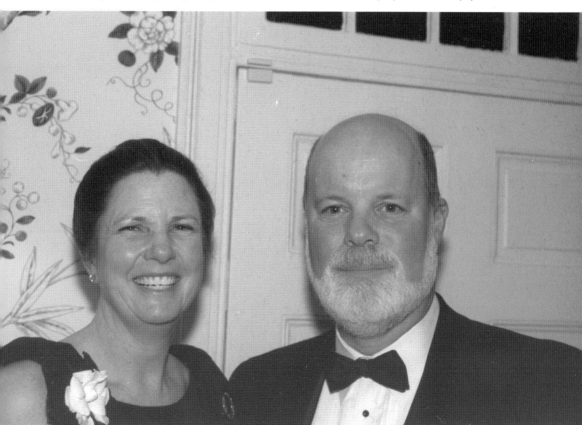

Ralph Klein

In 1949, Ralph Klein and his father, Maurice, opened a general store at Rocks and Jarrettsville Roads in Forest Hill. It was an emporium of essential goods for residents of a still rural county. Naturally, there were groceries and fresh foods. However, it was also the go-to destination for country-living necessities like penny nails, duck calls, fishing or hunting licenses, dungarees, and canning jars. Few questioned Klein's motto "100,001 items under one roof. "

Ralph saw the future, though, in a bucolic county that was only 45 minutes north of Baltimore and undergoing post–World War II changes. Over the years, new Klein's locations matched where Harford's growing population moved to live, work, and shop.

Demand for hunting rifles, tackle, and the like, of course, dwindled. Salad bars, unique spices, and home delivery became the 21st-century grocery business model. Klein's kept pace and thrived. There are now nine Klein's ShopRite supermarkets, six of which are in Harford County.

In 1953, Ralph married Shirley Snyderman, who soon combined the role of business partner with wife, mother, homemaker, and influential community volunteer.

As a mother, the lack of local health care concerned Shirley, who made frequent out-of-county trips to access regular and specialty health care for her growing family. Shirley, a member of the Upper Chesapeake Foundation, advocated publicly for a local state-of-the-art hospital. The Klein family contributed toward the establishment of the Upper Chesapeake Medical System, now a landmark at Route 24 and W. MacPhail Road. The Klein Ambulatory Care Center is a tribute to their vision of a healthier life for Harford County. To attract first-rate health care practitioners, the Kleins went on to develop medical professional buildings and an assisted-living facility near their store's Forest Hill headquarters. They also donated land for the Senator Bob Hooper House, a Forest Hill hospice.

Throughout unprecedented population growth in the area, the Klein family remains synonymous with textbook business success and life-changing (and life-saving) local philanthropy. (Jim Butcher.)

Robert Preston

Rob Preston continues the legacy started by his grandfather in 1926, when he founded Preston's Stationery on South Main Street in the first floor of the old Vaughn Hotel. The store initially offered magazines, newspapers and stationery, but these were augmented by any items customers wanted including shoestrings, tobacco, and even guitar strings. In 1946, after serving in the military, Donald Preston, Rob's father, joined the firm. The Prestons moved the store to its current location on South Main Street in 1968 before the devastating 1972 fire that destroyed their former location. After serving in the Navy, Rob joined the firm in 1972. Carrying on his family's tradition, Rob became president of the Bel Air Rotary, a county historical society trustee, and a town planning commissioner. He was elected a member of the Bel Air Board of Town Commissioners in 1997. He continues to serve in this capacity just as his father and grandfather before him. (Town of Bel Air.)

John Clay McComas

In earlier times, morticians generally combined their talents as cabinetmakers and undertakers. Such was the case with John McComas in Abingdon, Dean and Foster in Bel Air, and the Kurtz family in Jarrettsville. When not busy with funerals, undertakers constructed household furniture as well as caskets for their clientele.

John McComas opened his cabinetmaker and undertaking establishment in Abingdon just outside Bel Air in 1808. Over time, the family abandoned cabinetmaking and expanded to include a funeral home in Bel Air on Broadway as well as in Abingdon. Several generations later, the McComas family continues to serve the community, helping local families during bereavement. (Kathi Santora.)

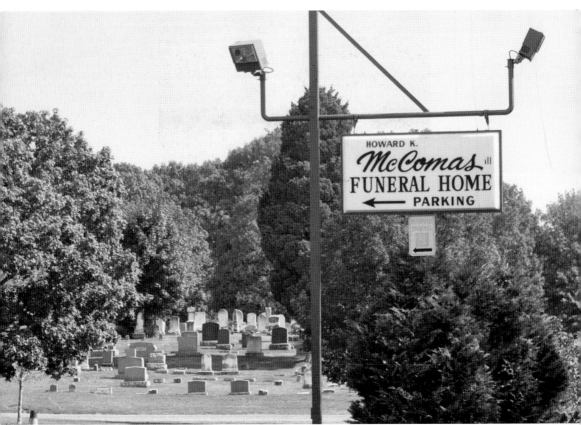

Solomon and Mary Getz

Few families can boast such a significant impact on the commercial and professional development of downtown Bel Air as the Getz family. Solomon and Mary Getz moved to Bel Air from Duncannon, Pennsylvania, in 1895. The Getz family then opened a clothing store in a rented storefront on Main Street and eventually purchased 26 South Main Street where they could operate their store and house their growing family in the upstairs apartment. They had four sons, Louis, Simon, Meyer, and David, and two daughters, Rebecca and Hattie.

The girls followed a traditional path, marrying and becoming homemakers. The sons became pillars of the downtown business and professional community. After Simon's retirement, Louis took over the clothing business, living in the apartment above the store and operating the clothing store until his retirement in 1965, when he turned the building over to his three sons, all lawyers. Their legal offices continue to provide services to the community from that location. Morton, the oldest son, died in the early 1990s; Stanley and Alan have since retired. However, Morton's son Stewart remains in law practice.

Simon opened a jewelry store when he was still in his teens, first in a corner of his father's store and later on Courtland and Main Streets. When he graduated from college as an optometrist, he expanded his business with a portion of his building serving as his optometry office and the remainder set aside for the jewelry business, which his wife handled. Eventually, his son Payson took over the jewelry operation, and Getz Jewelers moved to Harford Mall in the 1970s, making it one of the first Main Street businesses to relocate. Simon's son Marvin went on to become an optometrist, separating the two businesses after years of coexistence. Both Simon and his son Payson served as town commissioners. Payson also served many years on the Board of the Bel Air Volunteer Fire Company.

Meyer became an attorney and held the distinction of becoming the first person of the Jewish faith elected as state's attorney of Harford County, a major accomplishment in the late 1920s. Their brother David became a pharmacist and owned a drugstore on Office Street, which was a gathering place for the local courthouse crowd for many years. (Stewart H. Getz.)

Charles Liddon Lutz

The consummate entrepreneur, Lutz dropped out of school in the eighth grade and took a job as a store clerk. He went on to become a multimillionaire as an appliance dealer and commercial real estate developer, while retaining his reputation as a quick-witted, generous man who was always ready to help enterprising young people get a start.

Working in Leland Reckord's radio shop, Lutz developed a fascination with electronics. Eventually, he rented space in other businesses and began selling appliances. In 1945, he purchased two Main Street residences and built his own store. The grand opening in August 1947 was a huge success, partly due to pent-up demand from World War II and partly due to Lutz's marketing genius. The *Aegis* reported, "From the red and black plastic facade with its ornamental neon signs . . . the three-story concrete block building is modern in every detail—streamlined for efficient utility." A crowd of 5,000 to 6,000 people gathered for the event.

Lutz installed a television set at the local American Legion and advertised that it was used nightly for the reception of sports events. He also invited customers to come to his store on Monday nights to view the fights on an 18-by-24-inch television screen. Success followed quickly; his service department alone employed 20 people.

Meanwhile, Lutz started buying old buildings and renovating properties on an average of one a year. He also opened a nursery on Baltimore Pike to nurture his love of gardening. A small man in stature, he left an indelible mark on Bel Air.

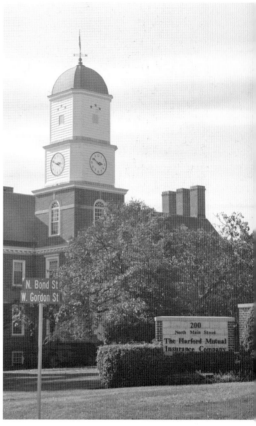

George Richard Cairnes

After a public hearing at the courthouse in 1842, the Mutual Fire Insurance Company requested the state legislature's permission to "make insurance on any kind of property against loss and damage by fire." Approval came quickly, and the new company included 15 prominent businessmen from Baltimore and Harford Counties. In 1883, George Cairnes became the company's secretary-treasurer, a post he held until his death in 1924.

Cairnes, a Civil War Navy veteran, served on the Baltimore Clipper ship *Macauley* commanded by Capt. John Rodgers. After the war, he taught for a few years and then served as the secretary-treasurer of the Board of Commissioners of Harford County before accepting the insurance company position. In 1904, he brought his daughter Annie Hope Cairnes into the company as his assistant. She went on to become the director of the claims department and the first woman to work as an officer in the company.

Cairnes's unprecedented tenure saw the company's major expansion and its increasing role as a community employer and benefactor. Eventually, the company's name was changed to Harford Mutual Insurance Company. It remains one of the largest employers in Bel Air. (Left, Harford Mutual; right, Kathi Santora.)

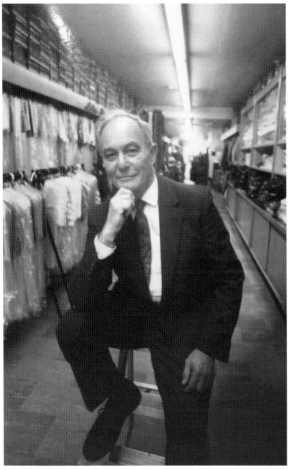

David Cohen

For 70 years, David Cohen began his workday by sweeping the sidewalk of Hirsch's Men's Store. He then stepped inside, draped a tape measure around his neck and readied for another day of outfitting just about every businessman, groom, schoolboy, prom-goer, police officer, firefighter, military man, and Boy Scout in Bel Air. He was known to provide loaner suits to farmers for a funeral.

Cohen was a Drexel University mechanical engineering student when he met Hannah Hirsch, whose father owned Hirsch's Men's Store. During their courtship, he commuted on weekends to Bel Air by bus and worked in the shop. In 1938, his future father-in-law asked him to take over the store, which measured a mere 16 by 120 feet. Cohen's mechanical skills kept the sewing, hemstitching, and pressing machines in top shape. He remained a Main Street retailing fixture until he retired at 90 years old in 2007.

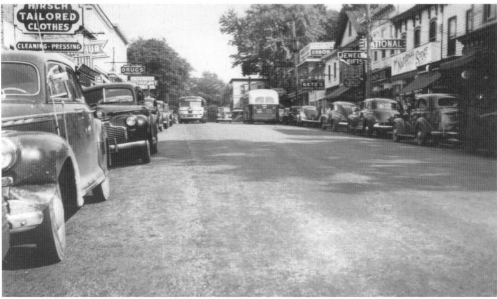

William Kelly

Opportunity sometimes comes in the most adverse circumstances. Kelly's position as First National Bank comptroller seemed secure after 18 years. Then, like many others caught in the bank takeover frenzy of the 1990s, he was ousted and caught in the recessionary cycle.

He opened his own certified public accounting firm and found that he enjoyed the independence. After attending a wealth management seminar, he expanded into this field and became a certified financial planner. Meanwhile, his nephew Bryan Kelly, an investment advisor with Fidelity Investments, suggested they form a partnership. This led to the formation of the Kelly Group in 1997.

At first it was just Bill (right); his wife, Lois; and Bryan (left). They built their business, the Kelly Group, slowly. In the beginning, they would send out seminar invitations to thousands of people. Sometimes, only a handful attended, but these customers spread the word. The business now includes two beautifully restored historic buildings on Gordon Street and a staff of 18. (Both, Kathi Santora.)

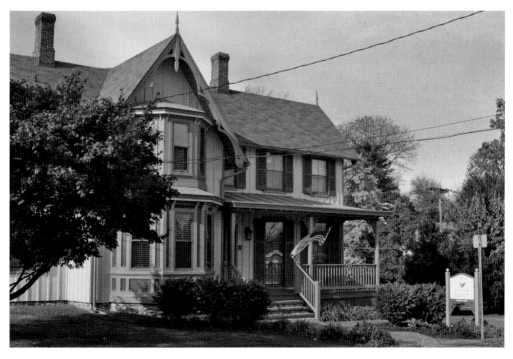

Virginia Taylor

In the 1970s, Bel Air was only a decade beyond a contentious public school system desegregation. At Toy Town U.S.A., however, manager Virginia Taylor hired people from all nationalities and lifestyles, remembers her daughter Chrita Paulin. "My mother embraced diversity before it was the 'it' thing to do," says Paulin, who preserves stories about Bel Air's historically African American neighborhood, located off Bond Street.

Born in a pink house on Alice Anne Street, Taylor lived there her entire life. A single mother with six children, she was first hired as a Toy Town cashier. Once manager, she was one of the few African American women at the International Toy Show in New York City.

She was also a quiet community activist who advocated for neighborhood children and wrote letters when she saw wrongs. Taylor remained a lifelong member of New Hope Baptist Church. (Chrita Paulin.)

Pota Panos Ayres

Pota Panagiotopoulos came from a small village near Sparta, Greece. When she was 15, she arrived on a ship at the New York Harbor with a tag around her neck that stated her name and included a note saying that her father was a candy maker at Lexington Market. She also carried $25 in cash. She spoke no English and wandered around until she drew the attention of local police officers. Somehow they helped her get to Baltimore and find her father. Three years later, her father and his fellow candy maker Nick Panos opened a candy store in Bel Air. They traveled to Bel Air by horse and buggy on a Sunday morning, carrying all their earthly belongings. The year was 1918, and Main Street's Candy Kitchen opened the next day.

The Sunday after the move, Pota's father told her that he had arranged for her to marry Nick. Luckily, according to her, she liked Nick, and together they operated the store, making all types of confections and raising their five children until Nick's death in 1936. This created several dilemmas for the young mother. Her husband was the candy maker, and she had to continue the business to support the children. She changed the business to a beer and luncheonette establishment since the Prohibition era was over and drink was in demand.

Reportedly, Mrs. Panos was one of the most industrious merchants in town, working 12 to 14 hours a day, cooking, serving and singlehandedly tossing out anyone she felt was disruptive or disorderly. Then, she walked home after closing each day to the family home on Broadway.

After World War II, she married Earl Ayres and remained with him for 27 years until his death in 1973. Miss Nick, as she was known by many of her customers, ran the store until 1990, when her son Peter Panos took over. Old-timers still reminisce about the hot dogs, beer, and, of course, "Miss Nick." (Sam Holden.)

Larry Dean

Larry and Julie Dean purchased Bel Air Liquors in 1997, continuing an established business in a strip shopping center across from the Bel Air Volunteer Fire Company. A few years later, they found that Harford County was purchasing the property for a proposed office complex. Dean had always wanted to build a place of his own and found the perfect location at 315 South Main Street.

The new building fulfilled his dreams of something larger, greener, and still within the Town of Bel Air. The result is a turn-of-the-century-style, 8,700-square-foot building that melds old and new. The store has hardy plank siding, stained concrete floors, and half-century-old architectural shingles combined with high-efficiency heat pumps and LED lighting. With an artful combination of old and new, Dean owns one of the most energy-efficient buildings in town. His dedication to his customers and his community continue to seal his reputation as a committed downtown merchant. (Kathi Santora.)

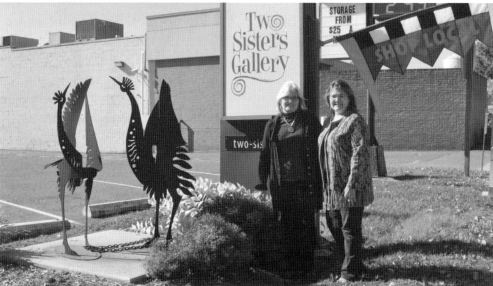

Bonnie Hardy and Debbie Haywood

Bonnie Hardy and Debbie Haywood opened Two Sisters Gallery, Bel Air's first fine crafts store in 2003, and now represent over 100 national artists. They will gladly share a quick lesson on the difference between fine American craft and chain store products. Touch the silky finish on a wooden box, they say. Focus on precise detailing on handmade beads. Skim the fluid curves of handblown glass. The message is clear: as opposed to chain store items, American crafts become family heirlooms. The sisters, ever promoting the arts, also commissioned one of Bel Air's first exterior murals on the side of their building and sponsored one of the first outdoor sculptures at Rockfield Gardens. (Kathi Santora.)

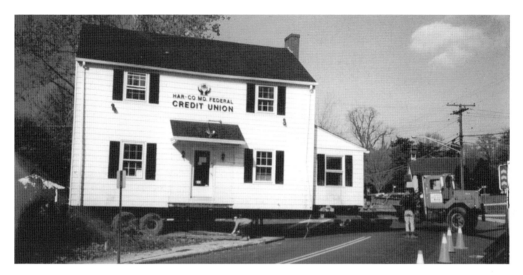

Ann Marie Navin

Though HAR-CO Maryland Federal Credit Union now occupies an 11,000-square-foot building at Lee and Hickory Avenues, it came to life in the basement of Frank and Ann Marie Navin's Wakefield Meadows home in 1965.

Ann Marie, who served as president/chief executive officer for the next 30 years, set up shop with a file cabinet, ledger, and an adding machine. Herbie, the family's Half-Moon Conure parrot, flew down the stairs to greet customers.

As HAR-CO introduced payroll deductions, credit cards, and ATMs, the credit union blossomed and moved into a colonial-style house across from the present-day Bel Air Town Hall and then into its current facility. Ann Marie's customer service style remained unchanged. "My job was to be with the customers as much as possible. If there was a long line, I walked with them to catch up on the news of their lives." (HAR-CO Maryland Federal Credit Union.)

Mel Machovec

Even some of Mel Machovec's best friends were flabbergasted when he announced plans to open a surf shop in landlocked Bel Air. Machovec was a lifelong surfer and skateboarder who included a skateboarding half-pipe in his basement when he built his Fallston home. The shop was a dream not yet come true until 2006, when he spotted a "For Rent" sign on a modest Bond Street Cape Cod–style building. He gutted and renovated, topped the roof with a surfboard, and stocked his store with the brand names that draw loyal surf and skate enthusiasts. In 2013, Machovec expanded Stalefish Board Co. and relocated to 100 North Main Street, one of the premier retail locations in town. (Kathi Santora.)

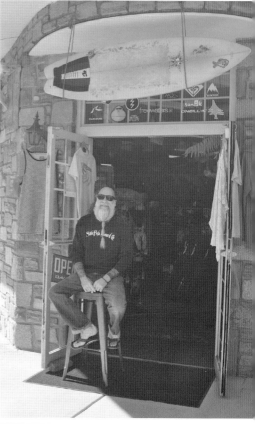

Maria Boeri

Maria Boeri likes to credit her staff for Savona Fine Italian Foods & Wine's success over the past 10 years; however, plenty of devoted customers credit Maria's welcoming smile, tasty food, and free Saturday wine tastings. The shop is located on the corner of Main Street and Pennsylvania Avenue. Her prime corner location includes a stellar view of downtown's comings and goings. (Kathi Santora.)

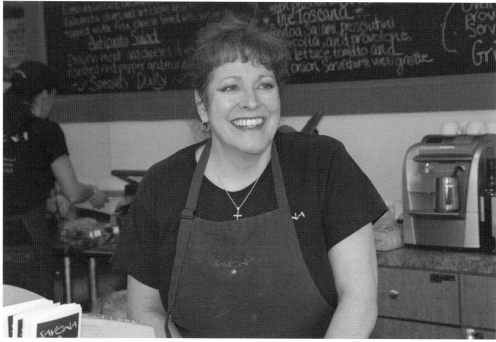

CHAPTER FOUR

The Regulators

Governing is never easy. There are disagreements, differing opinions, and disputed taxes. The public expects basic services, like roads, schools, and crime and disaster response. As a county seat, Bel Air provided a natural meeting location for politicians, attorneys, and judges. Initially, the state appointed county commissioners, the sheriff, and judges. Once the electoral system was established, voters decided on representatives, but the state still retained the final authority over county legislation. In 1974, Harford County voters adopted home rule, changing from a commissioner form of government to a county executive and county council form. This provided more autonomy for local citizens and often more controversy as the elected county executives, county council members, and state representatives sought to meet the needs of a metropolitan county in the throes of growth.

In 1874, the state approved incorporation status for the Town of Bel Air, creating one of only three municipalities in the county. This gave Bel Air citizens the right to establish their own government with a separate town manager responsible for daily administrative function and five commissioners who provide guidance and oversight. This governmental structure preserved Bel Air as a close-knit, small-town enclave in the midst of a busy suburbanized development corridor. The commissioners set the tone for development, assuring that its scale is manageable, that the recreational needs of its citizens are satisfied, and that public services remain exceptional. They oversee public employees who police, manage traffic, remove snow, and deliver waste, water, and sewer services. Along the way, they also assure the quality of local life by supporting festivals, parades and events that make life in Bel Air so enjoyable. However, they face a major conundrum—how to deal with the issues of Greater Bel Air as the area outside town boundaries grows incrementally. Many of those who served Bel Air went on to serve in county and statewide positions with the hope of addressing some of these growth issues.

The men and women described here made their mark both locally and nationally. Robert Archer's career impacted the state road system, national conservation legislation and immigration laws. Mary Risteau was elected to the state legislature just a year after women won the right to vote. She went on to a precedent-setting career in state and local government. While this is a small sampling of the regulators who led the community through good times and bad, it hints at the quality of people who served Bel Air and Harford County.

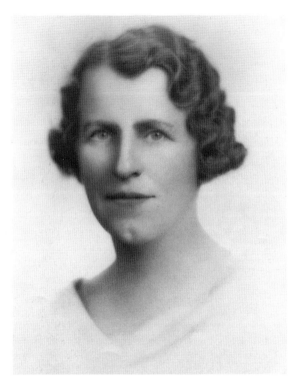

Mary Eliza Watters Risteau

Just one year after the 19th Amendment provided women with the right to vote, Harford citizens elected Mary Eliza Watters Risteau to the Maryland House of Delegates. Clearly, they recognized a born leader.

Risteau, "Miss Mary" to neighbors and friends, was the first woman elected to the Maryland House of Delegates. Not resting on that distinction, she was later the first woman in the state senate as well as on the Maryland State Board of Education. A career politician at a time when most women had few career choices, Risteau was also the first woman delegate to the 1936 Democratic National Convention. The Third Circuit Court of Harford County appointed Risteau as clerk of the Circuit Court of Harford County in 1937. Again, she was the first woman to hold that position.

As with most natural leaders, Risteau showed signs of early activism. She was born on April 4, 1890, and began her career as a Baltimore County teacher. She was active in the Towson High Alumni Association, the Baltimore County Teachers Association, and the Baltimore County Teachers Retirement Association. She is remembered for collecting $600 in pennies from students to purchase a portrait of Cecilius Calvert, 2nd Baron Baltimore from its painter, Florence MacCubbin. The painting hangs today in the Maryland House of Delegates Chamber.

In 1917, she became a Harford County resident when a series of family events and deaths caused her to take over management of Eden Manor, the family farm in Sharon (near Jarrettsville).

Her House of Delegates election in 1922 started her path to a visible political career. She served in the House and Senate through 1937. During that time, she earned a law degree from the University of Baltimore.

Risteau did not shirk from hardline campaigning. In 1937, she briefly sought the nomination for the congressional seat from Maryland's second district, reminding potential voters that incumbent Street Baldwin frequented Pimlico horse races and Florida betting rings instead of attending to his congressional duties.

Today, the Mary E. Risteau Building carries on the spirit of her legal, political, and agriculture career and life in Harford. It is the home of the district court; Bel Air's weekly farmers' market takes place in its parking lot.

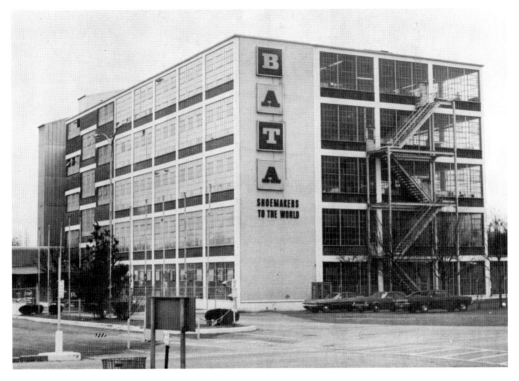

Robert Harris Archer

Archer left his Bel Air law practice in 1916 to serve as a lieutenant in the 1st Maryland Infantry. He was sent to the Mexican border and later to France with the 29th Division to fight in the Meuse-Argonne offensive. He was promoted to major after this battle; thus, his longtime nickname, "Major Bob."

On returning home he resumed his law practice, receiving an appointment as special assistant attorney general for the State of Maryland in 1923. One of his notable successes was the battle against the Pennsylvania Electric Company for taxes owed to the State of Maryland on the Conowingo Dam project. The case ended in a Supreme Court decision guaranteeing Harford County an additional $100,000 in revenue for many years.

By 1930, Major Bob was the undisputed leader of Harford's Democratic Party, exerting a tremendous influence upon local legislation, the selection of candidates, and the general administration of county offices. He resigned as attorney general and became counsel to the State Roads Commission of Maryland, writing much of the law that resulted in the current state highway system. In 1931, he joined the firm of his lifelong friend and ally Sen. Millard Tydings and became a conservation advocate. He drafted much of Maryland's conservation legislation and served as chairman of the Maryland-Virginia Commission on Bay and Potomac River Problems.

Locally, one of Major Bob's most challenging cases was as counsel to the Bata Shoe Company. In 1939, he opposed the ruling of the US Immigration and Naturalization Service in preventing the admission of 100 Czech employees who were to serve as instructors at the recently completed Bata Shoe Company in Belcamp, Maryland. The case pitted him against such foes as Sen. Joseph McCarthy.

Hoping to bring employees out of Czechoslovakia before the imminent Nazi invasion, owner Jan Bata built shoe manufacturing operations in Canada, South America, and Harford County. Some locals believed, without any proof, that the immigrants might be communists or Nazis. On arrival, Czech workers and their families were met with hostility, forcing many to leave the country for South America and Canada or face deportation back to the now Nazi-occupied Czechoslovakia. Archer's persistence and skill helped maintain access and eventual citizenship for many of these workers, preventing their forced return to a Nazi-occupied country.

June Weeks

June, a native of Scotia, New York, taught high school French in Fort Ticonderoga, New York, before marrying Maurice Weeks, a toxicologist and pharmacologist, in 1948. When Maurice accepted a position with the Army Environmental Hygiene Agency at Aberdeen Proving Ground in 1953, the family moved to Bel Air.

Always interested in government, June helped organize the Harford County Chapter of the League of Women Voters and twice served as its president. Seeing numerous issues confronting the town and the county, she volunteered her expertise and accepted an appointment to the town's planning commission and the Harford County Charter Board whose work led to the establishment of county's charter government. In 1976, she was elected to the Board of Town Commissioners and became Bel Air's first female mayor in 1977, serving until 1985. (Above, Kathi Santora; right, Town of Bel Air.)

John Wiker Schafer

An avid sportsman and master of many trades, Schafer played semiprofessional baseball for the Susquehanna League. He was a talented and scrappy infielder with potential for the big leagues. He also worked at a local cannery and as a mechanic in his family's garage on Route 1. With the bombing of Pearl Harbor, he was called to serve in the Army and was assigned as a mechanic in the North Africa Corps, where he sustained a serious head injury, resulting in a six-month hospitalization.

After the war, he returned home to his father's garage before accepting a position as a salesman and manager at Plaza Ford. He eventually followed his dream of participating in the political arena when he was elected in 1974 to the Harford County Council where he served an unprecedented 16 years. He was instrumental in the acquisition of Liriodendron for use as a county park as well as the placement of the War Memorial next to Bel Air Town Hall. Schafer was generally revered as a regular guy with a big heart. He was sensitive to the needs of the public and worked tirelessly, generally behind the scenes, to meet the needs of his constituents.

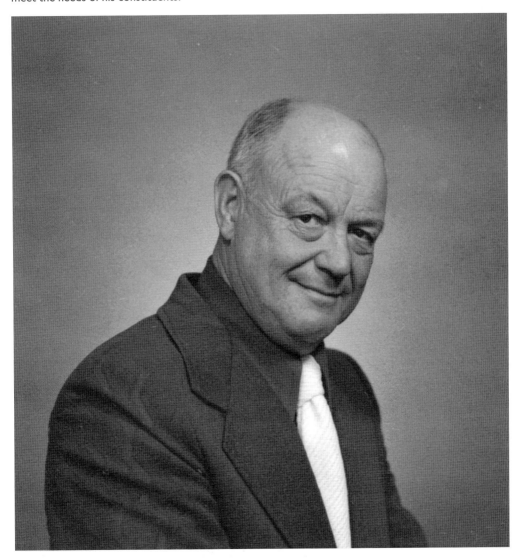

William N. Mc Faul III

West Point graduate Bill McFaul served a three-year tour in the Artillery in Heidelberg, Germany. After earning an engineering degree at the University of Arizona, he went to Korea as the commander of an ordnance company. For the next three years, he was the executive officer for the Sheridan Project and an advisor in the Military Assistance Command in Vietnam, returning to Aberdeen Proving Ground with two Bronze Stars.

After retiring from the military, he became Bel Air's first planning director, ultimately moving on to become town administrator in 1979. This second career allowed McFaul to use his strong organizational skills and fiscal talents to see Bel Air through the tremendous growing pains of the 1980s and 1990s. He served 20 years as the town administrator.

Charles B. Anderson Jr.

Harford County adopted charter government in 1972, moving from a board of county commissioners to a self-governing home rule government operating under a charter with an elected county executive and county council. Charles B. Anderson Jr. was on the County Board of Commissioners from 1970 to 1972, and after campaigning for the new form of government, he was elected the county's first county executive in 1972, serving two consecutive four-year terms.

Anderson grew up in Joppa and attended Old Post High School and Capital University in Columbus, Ohio, before joining the US Marines in 1951. In 1953, he returned home to work in the family's hardware store and lumberyard, Anderson's Hardware, in Joppa. In 1965, he started Harford Sands, a sand and gravel business.

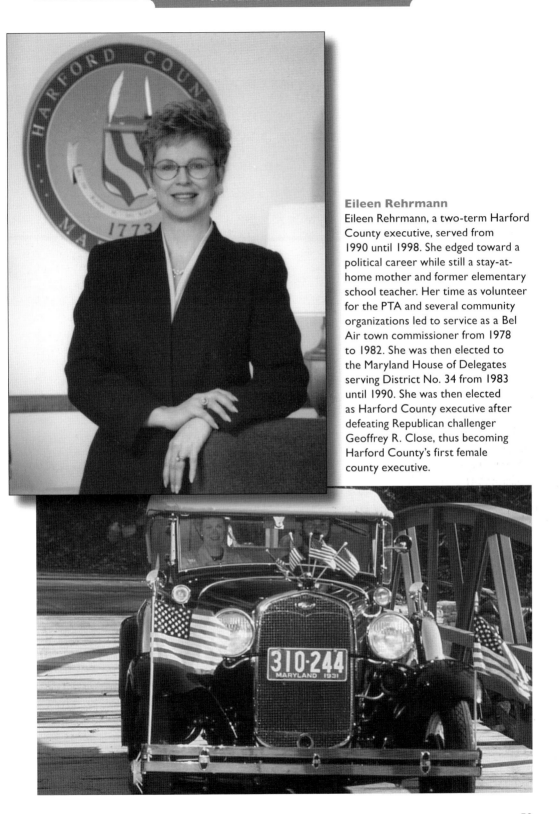

Eileen Rehrmann

Eileen Rehrmann, a two-term Harford County executive, served from 1990 until 1998. She edged toward a political career while still a stay-at-home mother and former elementary school teacher. Her time as volunteer for the PTA and several community organizations led to service as a Bel Air town commissioner from 1978 to 1982. She was then elected to the Maryland House of Delegates serving District No. 34 from 1983 until 1990. She was then elected as Harford County executive after defeating Republican challenger Geoffrey R. Close, thus becoming Harford County's first female county executive.

William Cox

Bill Cox, just 28 when elected in 1971 to the first of five terms as a Maryland State Delegate, recognized that Harford County was on the brink of transformation from a sleepy rural Baltimore outpost to a burgeoning suburb. He instinctively knew that road, school, and infrastructure development, though controversial, would keep the county viable.

He supported and helped secure government funding for Route 24, which leads from Interstate 95 into the Town of Bel Air, one of the most symbolic local road projects of the 1980s. The new road separated the Durham Farm at Route 1 and forever changed the local economy from farm to retail.

Today, Cox operates a real estate company in the Hopkins House, a historic property at 141 North Main Street. He is a founding member of the Greater Harford Committee and the Greater Bel Air Community Foundation. (Both, Kathi Santora.)

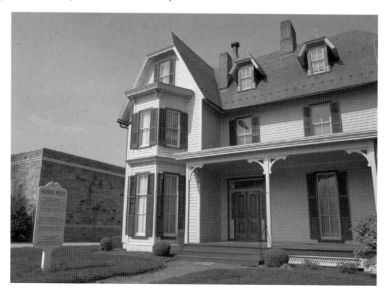

Donald Fry
Colleagues regard Don Fry as the rare community leader who understands the big picture as well as the nuances of both government and business. The combination makes him the ideal leader for the Greater Baltimore Committee (GBC), a business and civic organization that works to sharpen the region's economic edge. Fry traces his passion for political and community action straight back to Bel Air Junior and Senior High Schools. He was first hooked in 1968 when teacher Chuck Robbins charged his students to organize a mock national political convention. Later, with a law degree from the University of Baltimore, Fry practiced in Harford County and also represented District 35 A in the Maryland House of Delegates. Fry volunteers for numerous nonprofits, boards, and community groups, including on the Board of Directors of Harford Mutual Insurance Company. (Kathi Santora.)

Susan McComas
Susan McComas is a familiar face in both Bel Air and Annapolis, where she has represented District 34 B (now 35 B) in the Maryland House of Delegates since 2002. Her political path started on the Bel Air Board of Town Commissioners, serving from 1987 until 2002. Later, as a state representative, she provided a crucial vote that helped fund Bel Air's Main Street upgrades. She has advocated for public safety issues such as prosecution of drunk drivers and gang members. McComas has also served on state task forces that studied issues related to child support guidelines, child custody, teen drivers, and child abuse and neglect. (Kathi Santora.)

Joseph Cassilly

Joseph Cassilly became the youngest elected State's Attorney in 1982, joining those family members whose names dot Harford's political and military history.

Cassilly served as an Army ranger during the Vietnam War. Seriously injured in 1970, he returned home and eventually became an attorney. He was never interested in practicing anywhere but in Harford County. When sworn in for his ninth term in early 2015, he became the longest serving State's Attorney in Maryland.

Many supporters say that his greatest contribution was early advocacy for a mental health court and a mediation program, both designed to help individuals with low-level charges stay out of the criminal justice system and receive treatment. For Cassilly, justice is not only about winning a conviction but finding a humane way to help vulnerable people rebuild their lives in the community. (Kathi Santora.)

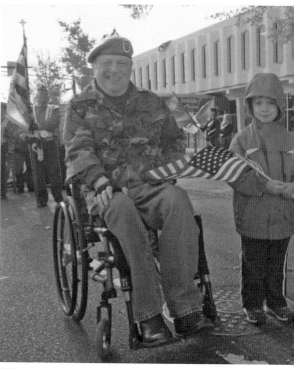

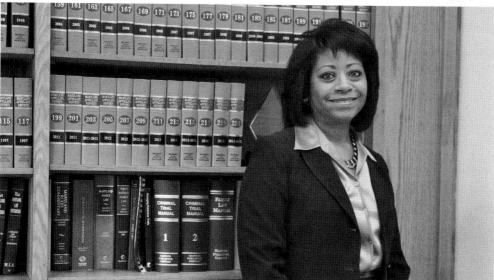

Angela Eaves

When Angela Eaves was appointed as an associate judge on the District Court of Maryland in March 2000, she became the first African American and just the second woman appointed to the bench in Harford County. The daughter of a noncommissioned Army officer, Judge Eaves attended school in dozens of cities and absorbed an understanding of this nation's cultural diversity. She brought this unique perspective to her interest in family law, child custody issues, legal rights for the impoverished, and support for local affordable housing. (Kathi Santora.)

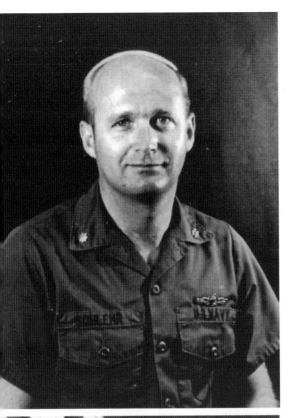

Christopher Schlehr

Chris Schlehr had football in his sights when he was accepted into the US Naval Academy in 1968. After all, he was part of Coach Al Cesky's legendary undefeated Bel Air High School team. However, life and world events directed him elsewhere. Instead, Schlehr, fresh with a bachelor's of science degree in mechanical engineering, was assigned as a gunnery assistant aboard the USS *Edson* (DD-946) just months after the January 1973 ceasefire that ended the Vietnam War. For the next two years, the *Edson* shadowed minesweepers that recovered previously planted US mines in the Haiphong Harbor in the Gulf of Tonkin. The USS *Edson* also escorted the first Vietnamese refugees to Guam and continued to provide this humane mission for the next two years. In June 1975, the *Edson* also evacuated US personnel from Saigon. Later in the decade, Schlehr was the chief engineer aboard the USS *Kilauea* (AE 26) that rescued Vietnam boat people and transported them to Singapore.

Schlehr retired in 1992 from a 20-year naval career that had taken him to far-flung national and world ports. He relished the return to his Bel Air roots and was hired by the Town of Bel Air as the public works director. When Bel Air town administrator William McFaul died in office, Schlehr assumed the responsibilities of interim, and then permanent, town administrator.

Described as a modest and deliberate leader, Schlehr's legacy includes the innovative purchase of the state-owned Milton Reckord Armory and its transformation into a community and arts gathering place. He also oversaw the development of Rockfield Manor, the establishment of the Main Street Maryland Program, and the later streetscape renovations. (Above, Chris Schlehr; below, Laura Stafford.)

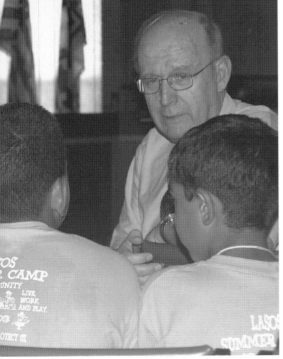

Leo Matrangola

Bel Air police chief Leo Matrangola loved details. His uniform was tack-sharp, no matter the time of day. Precisely stacked paperwork on his desk usually included details about training programs and equipment designed to grow the skills of his police force. When needed, his hand would hover over a bulging Rolodex and land on just the right person for the situation at hand. He was quick to brag on his officers and their accomplishments and slow to self-promotion.

When he died in 2015, his memorial service took place at the Bel Air High School auditorium because no church in town could hold the number of colleagues, friends, and residents who came to pay their respects.

Before his appointment to the Bel Air Police Department, Chief Leo had completed a 21-year first career as lieutenant and supervisor in the Baltimore County Police Department narcotics unit. In 1991, at the age of 39, he started a second career as the police chief of Bel Air, his hometown. The chief's arrival coincided with one of the most dramatic economic and population growths ever seen here. Matrangola set out to make sure that a small rural police department was up to the challenge.

Over the years, Matrangola advocated for changes that would build a solid police force: technical training, better pay and retirement benefits, up-to-date uniforms, comprehensive manuals, state-of-the-art vehicles, and participation in a multijurisdiction SWAT Team.

He understood the importance of image in law enforcement. One year, Matrangola arrived at the Bel Air Holiday Parade with one of his family horses. An officer who recalled the event stated, "He threw a police blanket and saddle on his horse and joined the parade. People thought we had a mounted unit." (Don Stewart.)

CHAPTER FIVE

The Entertainers

By the mid-1800s, technological improvements allowed for more leisure time. The Masonic Temple on Bond Street provided a venue for lectures, dances, and concerts. Actors like Edwin Booth performed at the courthouse and the Country Club Inn. The town supported several newspapers, some publishing twice a day. A Chautauqua visited the town each spring bringing nationally known lecturers, dramatists, and carnival acts to the school grounds for an entire week. The next century introduced movies, radio, and television. Local celebrities Capt. Jim McMahan and Bob Callahan brightened the airwaves on *Bob & Jim in the Morning* with entertaining banter that generated a cadre of followers who spiritedly participated in the show's morning call-in format. Locals would gather at the Bel Air Bakery to joke and entertain their fellow citizens.

For the more culturally sophisticated, Saul Lilienstein created the Bel Air Opera Company, which performed original productions for almost 20 years. Each summer, Lilienstein would gather operatic talent from across the country to summer in Bel Air and perform outstanding productions in a remodeled barn that brought audiences from throughout the region. Legend has it that the opera company's first productions were almost its last as they were accompanied by a cacophony created by the noise of a nearby farmer's tractor as he tried to drown out the music. On another occasion, this was followed by a torrential downpour as rains soaked the field where cars had parked for the performance. Still, the music survived.

Duke Thompson, a star Gershwin pianist, later opened the Maryland Conservatory of Music, providing young students with an opportunity to hone their skills and offering unique entertainment to area audiences.

Of course, entertainment extends beyond music and performing arts. Today, local artists are recognized and treasured, but this was not always the case. It was not until the mid-20th century that people, like Lois Reed and Mary Woodward, brought the exceptional local artistic talents to the forefront with the beginnings of the Bel Air Arts Festival, which continues today. Kate and Russell Lord helped generate the environmental movement through their publication and artwork in the locally published magazine *Our Land.*

Bel Air has produced more than its share of talented writers, musicians, performers, and artists. These range from noted newspaper reporters, like Edna Goldberg, to celebrated artists, like Jim Butcher and Barbara Love, whose work reaches international audiences.

Edwin Booth

From age 13, Edwin Booth accompanied his father, the famous Shakespearean actor Junius Booth, wherever the performance season took him. The elder Booth took Edwin ostensibly as his companion, but in reality, he was his father's caretaker, assuring that he stayed sane and sober. Edwin had a unique ability to read his father and to calm his often tempestuous temperament.

In the summer, they would return home to enjoy the relative calm of their farm, Tudor Hall, located just northeast of Bel Air. While there, Edwin performed locally at the old Eagle Hotel and the Bel Air Courthouse. He realized his great desire to follow in his father's footsteps when he made his official stage debut as Tressel in *Richard III* in Boston, Massachusetts, at the age of 16. Three years later, Edwin was performing in California with his father when the elder Booth decided to return East. Junius died en route home to Maryland. Edwin would eventually complete a worldwide tour that included Australia, Hawaii, and California.

Over time, he gained acclaim as a great Shakespearean actor in his own right. He managed the Winter Garden Theatre in New York City from 1863 to 1867, mostly staging Shakespearean tragedies. He played the title role in Hamlet for 100 performances, setting a record not broken until 1922, when John Barrymore played the title character for 101 performances.

In 1909, Robert Lincoln, Abraham Lincoln's son wrote a letter to Richard Watson Gilder, editor of *Century Magazine*, describing how Edwin had saved him from serious injury or even death in late 1864 or early 1865, shortly before Lincoln's assassination. Robert had fallen from a crowded train platform and found himself being pulled to safety by Edwin Booth, the noted actor.

Even today, many recognize Edwin Booth as one of the greatest theatrical performers of all time. In *Prince of Players: Edwin Booth*, Eleanor Ruggles describes listening to a recording of Booth's voice at the Harvard Theatre Collection in Cambridge, Massachusetts. She stated that "the voice itself was the most beautiful speaking voice I had ever heard, with great poetry and feeling, yet with no straining for effect, and I suddenly understood the ecstatic, nostalgic praises of the men and women, my own grandparents, for example, who had heard Booth in life."

New tower for HdG, new job for Mrs. Goldberg

Edna honored JAN 14 1987

Baltimore Sun reporter Edna Goldberg, left, receives recognition Monday night from School Superintendent A.A. Roberty and members of the Harford County Board of Education at the last school board meeting she will report. Mrs. Goldberg is retiring in February after covering the county for 18 years.

Edna Goldberg, a local institution, to step down

(See EDNA, Page 6A)

Edna Goldberg

Where's Edna? This was a familiar cry at the county office building where she seemed to be everywhere at once, always carrying her notebook. Considered an outstanding, natural reporter by her colleagues, she was the face of the *Baltimore Sun* in Harford County for almost 20 years. Nothing stood between Edna and a good story. She was very conscientious, a well-respected investigative reporter, always assuring that her stories were factual, thorough, well-written, and fair.

Like so many of Bel Air's residents, she was a transplant. The daughter of Eastern European immigrants, she grew up in the Bronx, New York, moving to Bel Air with her husband in 1953 after he was named contract attorney advisor at the Army Chemical Center at Edgewood Arsenal.

In 1969, while serving as president of the League of Women Voters, the *Baltimore Sun* newspaper hired her to cover Harford County. Timing was fortuitous. The county was on the brink of major change, moving to charter government; establishing the position of county executive; developing its first master plan; and eventually, establishing the much debated Development Envelope and Comprehensive Zoning Regulations.

As noted by her fellow reporter Allan Vought, "nothing escaped Edna, who could be a terror with a healthy dose of skepticism about politicians. She unearthed the foibles of numerous officials, reporting their screw ups and occasional downright fraud." (Kathi Santora.)

Kate and Russell Lord

Kate and Russell Lord published and illustrated *Our Land,* one of the first conservation journals in the country. They worked from the old Country Club Inn at Bond and Thomas Streets. It was the official voice of the Friends of the Land organization. The quarterly journal, published between 1941 and 1963, included articles from such luminaries as Rachel Carson, author of *Silent Spring;* Gifford Pinchot, nationally known conservationist; J.N. Darling of waterfowl fame; Bill Mauldin, cartoonist; E.B. White, author of *Charlotte's Web, The Trumpet of the Swan,* and *Stuart Little;* John Dos Passos; Louis Bromfield; Henry Wallace; James Thurber; and many other notable authors.

The Lords also played prominent roles in Franklin Delano Roosevelt's administration, Russell as a knowledgeable and accomplished agricultural expert and Kate as an illustrator and mapmaker. Her unique style captured such local landscapes as the Ma and Pa station and the Mill on North Main Street in the 1950s.

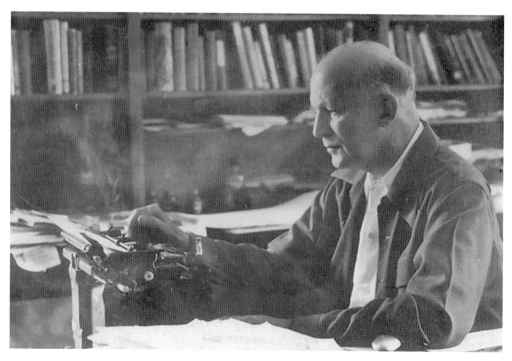

History

According to the history books, no Blacks, no Jews and only one Woman lived in Harford County, Maryland.

Yet in the record they are live beings, blood and brains, brawn and guts . . .

And graveyards are full of them, who never lived in the history books.

Mary Bristow, 1980

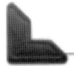

Mary Bristow

A nurse, poet, and journalist, Mary Bristow was a feisty and strong-willed individual who took on the issues of the day with great vigor. Her writing spanned topics of culture, art, history, poetry, and feminist issues.

Born Mary Reiter Smithson, she was placed in an orphanage after her father's death, leaving a lifelong scar. She graduated from Union Memorial Hospital's Johnston School of Nursing in 1947 and went on to work as a nurse at Union Memorial Hospital and the Maryland School for the Blind. Her love of music and culture was visible in her writing, poetry, and her memberships to numerous cultural organizations, including the Comic Opera Company of Baltimore, the Baltimore Symphony Chorus, and the Harford County Poetry Society. (Kathi Santora.)

Christopher Weeks

When his Bel Air High School classmates were rocking to 1960s music, Christopher Weeks happily absorbed opera, Broadway music, the game of bridge, and architectural principles. His passion for historic preservation steered him quickly past a brief stint in law studies and into a career of photographing and documenting Maryland's historic buildings and estates.

Weeks's books about Washington, DC, Talbot, Dorchester, and Harford Counties remain go-to references for preservationists. They include *An Architectural History of Harford County* and *Perfectly Delightful: The Life & Times of Harvey Ladew.* (Susan Tobin.)

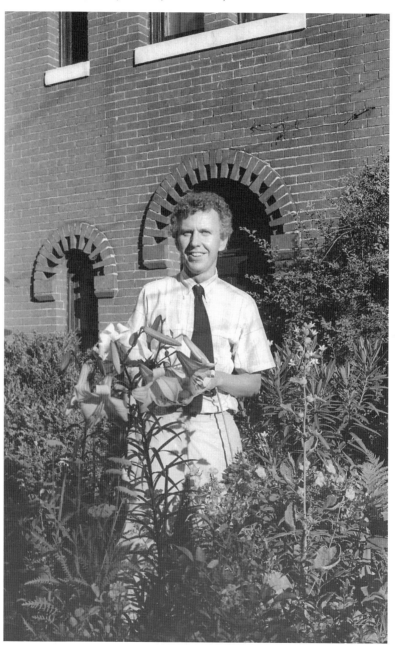

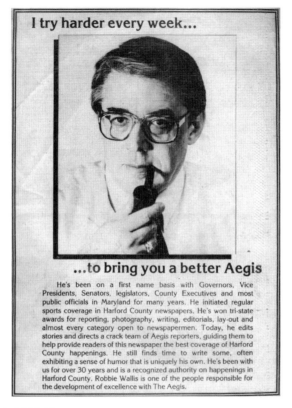

I try harder every week...

...to bring you a better Aegis

He's been on a first name basis with Governors, Vice Presidents, Senators, legislators, County Executives and most public officials in Maryland for many years. He initiated regular sports coverage in Harford County newspapers. He's won tri-state awards for reporting, photography, writing, editorials, lay-out and almost every category open to newspapermen. Today, he edits stories and directs a crack team of Aegis reporters, guiding them to help provide readers of this newspaper the best coverage of Harford County happenings. He still finds time to write some, often exhibiting a sense of humor that is uniquely his own. He's been with us for over 30 years and is a recognized authority on happenings in Harford County. Robbie Wallis is one of the people responsible for the development of excellence with The Aegis.

W. Robert "Robbie" Wallis

Few locals possess more ties to Bel Air's mid-century saga than Robbie Wallis. He was, at various times in his 77 years, a St. Margaret Parish altar boy, a special delivery letter bicycle carrier, projectionist (and later manager) for Bel Air's movie theater on Main Street, the *Harford Gazette*'s first sports writer, an Aberdeen Proving Ground information officer, and owner of the Capri, a Bel Air sub and pizza shop. He sealed his legacy, however, with a 38-year career as a reporter and, eventually, managing editor of the *Aegis* newspaper.

Wallis did not have formal credentials for many of these pursuits. *Harford Gazette* editor and publisher Paul Capron hired and mentored him just after his Bel Air High School graduation. In an informal autobiography, Wallis noted that, when he purchased the Capri, he knew little more than how to pour a bowl of cereal. However, friends and family say that he had a way of putting an indelible stamp on every endeavor.

Rarely spotted without his trademark smoking pipe, he pursued scoops on local news with zeal. Wallis rode along with local law enforcement, covered all varieties of sporting events, and stayed in step with political machinations, large and small. He progressed in the ranks and spent the last decade of his career as the *Aegis* editor in chief.

Wallis took card games and horse races seriously as well. Word is that the Bel Air movie theater lobby was the after-hours venue for many a card game among town insiders, including police officers, business owners, and various hangers-on. The Thursday night gin tradition with lifelong friend Paul Neeper endured 33 years and was documented with meticulous spreadsheets that tallied the pair's win-loss percentage.

Health issues dogged Wallis after retirement. He tapped out his pipe for the last time while sitting in the Johns Hopkins Hospital parking lot before his 1998 aortic aneurysm repair, a 13-hour surgery that saved his life but resulted in leg paralysis. He nevertheless spent the next 10 years with Sandi, his wife of 31 years, traveling the world and living at their homes in Las Vegas and Bel Air. (Sandy Wallis.)

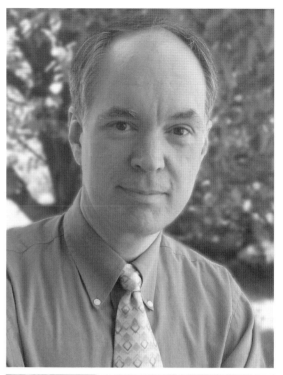

William Michael Bates

As a talented freelance writer and editor, Bates founded Harford New Media, Inc., a company that developed websites and media projects for businesses and organizations. After writing, editing, and taking photographs for many articles about county history and local organizations, as well as serving on and chairing several volunteer boards, including the Liriodendron Foundation, the Small Business Development Center, and the Harford County Chamber of Commerce, Bates became fascinated with capturing the uniqueness of the community he now called home. In conjunction with Arcadia Publishing, Bates became the author of Images of America: *Bel Air*; Postcard History Series: *Harford County*; Then & Now: *Harford County*; Images of America: *Havre de Grace*; and Images of America: *Aberdeen Proving Ground*. (Arcadia Publishing.)

Bill Bates

Henry Peden and Jack Shagena

In their search for close-to-forgotten icons of Harford County's past, Henry Peden and Jack Shangena have explored every paved and dirt road in Harford County, fended off growling dogs, and calmed irate neighbors. Their book series, *Harford County's Rural Heritage*, includes 14 editions that document mills, barns, spring houses, bridges, churches, and most recently, country stores, in meticulous detail.

Peden, a retired administrator, and Shangena, a retired engineer, say they have a yin-and-yang partnership, yet share what brings success to historical authors—the thrill of the chase, a desire to preserve the past, and a passion for connecting words and images. (Kathi Santora.)

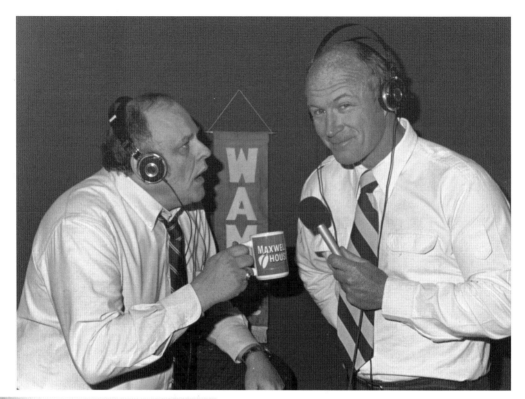

Bob & Jim in the Morning

Loyal fans of *Bob & Jim in the Morning* gathered in places like the Bel Air Bakery to keep up with the latest news. (Jim McMahan.)

Robert Callahan

A veteran broadcaster, Callahan started his career while still in high school, hosting *Teen Turntables* for WNAV-AM in Annapolis. Blessed with a deep, sonorous voice and a calm, pleasant manner, he became a natural for radio and, later, for television. Drafted in 1963, he spent his service career as an announcer for Armed Forces Radio and as a press liaison officer at the White House and Arlington National Cemetery. Over time, he hosted numerous television shows on WJZ, WBAL, and MPT in Baltimore. His longest running show, lasting 23 years, was in Bel Air with WVOB, and later WAMD radio, *Bob & Jim in the Morning.*

After retiring to Florida, Callahan continued doing voice overs and freelance performances. A certified scuba diving instructor and an avid cyclist, he participated in several Senior Olympics, winning multiple gold medals. (Lisa Callahan Golden.)

James V. "Captain" McMahan Jr.

A natural showman, Captain Jim, as he is known by all, is the son of Bel Air's long-term police chief J. Vaughan McMahan and his wife, Selena Pickett McMahan, a biology teacher at Bel Air High School. Although he served in the US Army Signal Corps and the Reserves as well as the Maryland State Defense Force, his nickname came from his years as WAMD radio morning show host. From 1978 until 2003, Captain Jim greeted Harford County residents, usually with his cohost Bob Callahan, with their special brand of repartee. Both had been affiliated with WBAL radio and television. McMahan served as general manager of WVOB in Bel Air for 10 years before he and some investors purchased the Aberdeen station in 1978. During this time, he also served with the Bel Air Volunteer Fire Company and is credited with founding the Bel Air Community Band and helping to start the Bel Air Fourth of July parade and celebration.

In 2003, he was elected to the Bel Air Board of Town Commissioners. In 2006, he successfully ran for Harford County Council and is now serving his third consecutive term as District C's representative. (Kathi Santora.)

Barbara Love

A talented artist, Barbara Love found inspiration in the Renaissance Masters and the Impressionists. Early in her career, she requested and received permission to paint at Giverny. This led to registration as a copyist at such renowned institutions as the National Gallery and the Musée du Louvre. She has painted copies of the works of such masters as Da Vinci, Rembrandt, Morisot, and Manet. Her original paintings and drawings can be found in private collections throughout Europe and the United States.

A natural leader and talented teacher, she has served as an officer and as a member of numerous statewide art organizations, including the Harford Artists Association, the Mid-Atlantic Plein Air Painters Association, and the Friends of Art in Bel Air. (Sandy Norris)

John F. Sauers

Sauers's artistic talents were recognized early. Upon graduation from Bel Air High School, he earned a scholarship to the Maryland Institute of Art. After completing his degree, Sauers responded to a Baltimore Gas & Electric Company advertisement seeking an artist with sketching ability. For the next 35 years, he worked as a graphic designer, drawing advertisements and illustrations for in-house publications.

For entertainment, he wandered downtown neighborhoods during lunch breaks with sketchbook and charcoals in hand, capturing the urban scene of the Inner Harbor, Federal Hill, Otterbein, and Fells Point, along with the street people in the area.

Sauers now lives in Darlington, where his grandfather was once a blacksmith. He continues to paint, teach, and support plein air painting throughout Harford County. (Kathi Santora.)

Todd Holden

Photographer and writer Todd Holden has chronicled some of the most memorable events and people in Harford County.

Holden's family owned the 565-acre Southampton Farm, once one of Harford's most productive dairy farms. In the mid-1960s, as a recent University of Maryland English literature graduate, he called the editor of the *Aegis*, the local newspaper, to question the accuracy of a story. In turn, he was offered a job as a reporter. During his days as a reporter, he wrote about and photographed memorable events such as the car bombing related to the H. Rap Brown case, the downtown Groundhog Day fire, and tropical storm Agnes.

He later operated Holden Studios Photography and Other Phenomena until 2003. He is still known as a Bel Air raconteur of local history, characters, and days gone by. His most recent book, *Son, You Turn a Good Phrase*, is a collection of some of these accounts. (Sam Holden.)

Mollee Coppel Kruger

Few former Bel Air High School newspaper editors have left a wider mark on the literary world than Mollee Coppel Kruger (pictured on the left). Her plays, essays, radio scripts, poems, newspaper columns, short stories, books, advertising copy, and letters to the editor span the decades and genres. Kruger's 2010 memoir, *The Cobbler's Last: A True Story of Hard Times, War, and the Journey of a Maryland Girl Who Lived over a Shoe Store on Main Street* provides a rare view of pre–World War II Bel Air from the vantage point of Coppel's, which was her parents' Main Street shoe store. (Kathi Santora.)

Duke Thompson

In the 1980s and 1990s, Thompson loved his dual careers as a music teacher in a Canadian college and a pianist who performed worldwide. However, he could not shake a vision of opening a music school where frequent public concerts, not just practice at home, would hone self-confidence and the joy of music.

While visiting his native Harford County, Thompson mentioned the dream to family friend Katharine J. Reese, a Havre de Grace education and culture supporter. In response, she provided start-up resources, and the Maryland Conservatory of Music was launched in 2002. Today, the conservatory's locations in Bel Air at St. Matthews Lutheran Church and downtown Havre de Grace offer a gamut of lessons from classical to rock.

Students appear regularly at the Bel Air Armory, community ceremonies, festivals, restaurants, and bookstores. Each Saturday morning, students present their latest musical accomplishments during a free, open-to-the public session. Thompson has also built a local legacy as an Abraham Lincoln aficionado. He frequently performs original interpretations of the life of America's 16th president. (Kathi Santora.)

Julienne Irwin

At 14, Julienne Irwin (pictured on the right with her father) had never had a singing lesson and had never performed for an audience. She did, however, faithfully watch television singing competitions. Irwin set her sights on *America's Got Talent* since there was no minimum age requirement. She "begged and coaxed" her doubting family to take her to audition. To the delight of her Bel Air friends and family, she progressed through eliminations and placed fourth in the final national TV finale in Los Angeles in 2007, after her performance of Taylor Swift's song "Teardrops on My Guitar."

Despite national notoriety, Irwin says that singing "The Star-Spangled Banner" at several Baltimore Orioles games rivals the thrill of placing on *America's Got Talent*. Irwin recently earned her college degree at Belmont University in Nashville and plans to release five original songs to kick off her dream musical career. (Irwin family.)

Stephanie Chervenkov
Stephanie Chervenkov entered the 2012 Miss Teen Maryland pageant on a bit of a whim. A John Carroll School student at the time, she had no professional coach or other supports enjoyed by longtime pageant devotees. The judges, however, saw a young woman of promise; she was an honors student, spoke fluent Bulgarian, volunteered at local nonprofits, and immersed herself in art and photography. She represented Maryland at the Miss Teen USA pageant held that year in the Bahamas. Today, Stephanie, now a College of Notre Dame graduate, is pursuing interests in marketing and yoga instruction. (Stephanie Chervenkov.)

Lois Butterworth Reed
From a tiny New York town, Lois Reed (pictured with her husband, Charles Reed) set out for Manhattan to study graphic arts at the Traphagen School of Design. Just before World War II, the city was a heady place of fashion, performing arts, and culture. After marrying Navy officer Charles Reed in California, she returned with him to his hometown in 1945, bringing her style and artistic flair to Bel Air.

The Reeds and their four children lived in a contemporary house on Catherine Street designed in conjunction with architect Duryea Cameron. Reed opened an art school, The Studio, with friend Mary Woodward in 1960. At a time when Harford County still struggled to implement the Brown v. Brown school desegregation decree, Lois ensured that her classes were open to all. Reed's artistic legacy lives on with the Harford Artists Association as well as the legendary annual Bel Air Festival for the Arts, both of which she helped found. (Susan Walls.)

James Butcher

Jim Butcher started his art training at Maryland Institute College of Art but left after a few semesters to enlist in the Marines. It was the mid-1960s, and he soon found himself in Vietnam assigned to a jet engine repair unit. One of his commanding officers learned of his art training and recommended him for the Marine Corps Combat Art Program. Within a short time, Butcher began his work as an art journalist covering the air war. He witnessed and recorded the Tet offensive as well as numerous ground battles. The Corps featured several of his illustrations in recruitment program ads, catching the eye of staff at the *National Geographic* magazine.

Once he completed his four-year stint in the Marines, he was recruited to illustrate *Undersea Treasures,* a National Geographic publication. This led to numerous commissions, including a project in Australia for *Trucks* magazine where he observed, reported, photographed, drew, and otherwise depicted the motor craft transport trade.

His commercial art projects included several movie posters for such blockbusters as *City Heat* and *Pale Rider* and covers for national publications like *Newsweek*. He received commissions from ITT, NASA, NBC, CBS, and others, expanding an illustrious commercial art career. However, Butcher's favorite role is that of visual biographer. Today, at his Bel Air home studio, he creates portraits and life stories in oil. (Kathi Santora.)

Saul Lilienstein
Renowned musicologist, lecturer, and conductor Saul Lilienstein brought opera to Bel Air in the 1960s and 1970s. He showcased his extraordinary talent as artistic director and conductor of the Harford Opera Theatre, bringing internationally known talent to Bel Air from Baltimore, New York, and San Francisco. The company performed a wide range of highly acclaimed operas in English, making them both entertaining and accessible.

After leaving Bel Air, Lilienstein went on to work with the Smithsonian, Johns Hopkins University, the Kennedy Center, the Washington National Opera, and at music symposiums in the United States and Europe. In 2005, the Wagner Society of Washington, DC, bestowed the society's award for "uncommon contributions" upon Lilienstein, joining past recipients Placido Domingo, Heinz Fricke, and other notable artists.

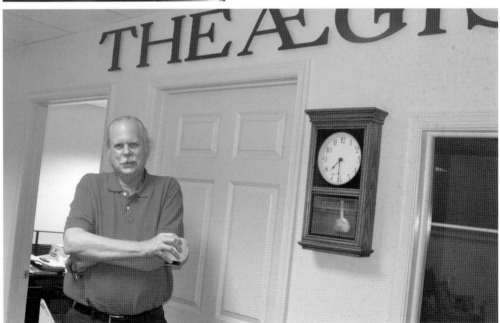

Kimber Allan Matzinger-Vought
In more than 43 years as an *Aegis* reporter and editor, Allan Vought has seen plenty of Bel Air news come and go. This is one newspaper veteran who does not necessarily long for the yesteryears of journalism. These days, says Vought, news businesses that have survived the electronic revolution can access and verify background details in record time, build better connection with customers, and measure their readership. All essential, he says, to making weekly newspapers a piece of the community's fabric. (Kathi Santora.)

Diane Lyn

In 1980, Diane Lyn, fresh from Harford Community College and the Broadcasting Institute of Maryland, read her first WVOB ("Voice of Bel Air") newscast. The 250-watt AM station broadcast from an *Aegis* newspaper building annex. Commercial radio was still a man's world, but Lyn had found her forte. She loved interviewing VIPs and musicians, chatting with listeners, broadcasting on-air classifieds, and introducing the latest hits.

Today, Lyn is a 35-year (and counting) Baltimore disc jockey and has broadcast from WLIF since 1999. Despite her Baltimore-based career, Lyn has stayed intensely loyal to her hometown. She and her husband live in and are painstakingly renovating the house in which she grew up.

To this day, Lyn looks back on those WVOB broadcasts and sees the framework on which she has built a notable radio career. (Kathi Santora.)

CHAPTER SIX

The Martial Element

From the earliest days of settlement, men from Bel Air served in the state militia, fighting in the American Revolution and, later, the Civil War and the Spanish-American War. Training took place in town fields. In 1915, the state contracted an architect to design and build the Bel Air Armory, which became home to local National Guard troops for almost 100 years. Troops gathered there for training and departure to foreign soils to fight in World War I, World War II, Korea, Vietnam, and the Middle East. Local women would often walk with the departing soldiers to the Ma and Pa Railroad station.

Pres. Woodrow Wilson had signed the Eminent Domain papers initiating the assemblage of land to create Aberdeen Proving Ground (APG) in 1917. This act changed the county and the town forever, modifying its economy and the nature of the surrounding communities.

At that point, the Bel Air Armory became a meeting place for area soldiers, Guard members, and local citizens. It became the location for dances, boxing matches, and other forms of entertainment for soldiers during wartime, both in the Guard and the regular Army. In addition to its military role, it served as a library, a Red Cross building, a motor vehicle administration facility, the prom and graduation hall, a talent show venue, a police training facility, and even a movie theater.

Over time, the Guard and armed forces included both men and women, and the local Guard unit changed from a cavalry unit to a helicopter unit. With the change and enhanced technology, the National Guard needed a more spacious location. The state transferred the Armory property to the town, moving the Guard unit to Aberdeen Proving Ground in 2006.

This chapter details the stories of just a few of Bel Air's residents who served in the military and on the local police force. Some, like Lt. Gen. Milton Reckord, started their careers in Bel Air. Others moved to Bel Air because of the military concentration at Aberdeen Proving Ground and Edgewood Arsenal. All served their country proudly.

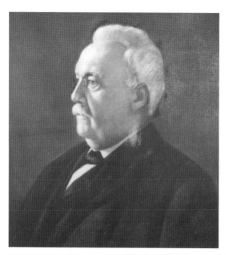

Otho S. Lee

Col. Otho Scott Lee, a distinguished Confederate soldier, was born in Bel Air and returned after the Civil War to build a memorable legal, political, and business career. He fought in the Confederate army from the first battle of Bull Run until the Appomattox surrender.

Upon his return, he took up his previously interrupted study of law and eventually became a respected leader in Harford County's bar association. Turning to politics in 1876, he became a member of the House of Delegates. His interests also extended to business. In 1893, he organized and became the first president of the Bel Air Water Company and also served as president of the Farmers and Merchants National Bank.

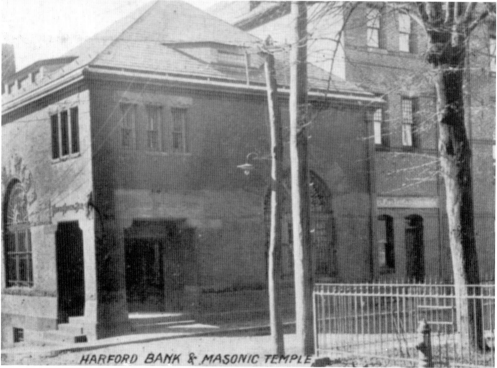

HARFORD BANK & MASONIC TEMPLE

Edwin Hanson Webster

A distinguished lawyer, Webster was elected to the Maryland Senate in 1855. In his second term, he rose to Senate president. In 1859, as the country grew ever closer to war, Webster was elected to the House of Representatives where he served three terms.

Webster strongly supported the Union. In 1862, while still a member of Congress, he recruited the 7th Regiment Maryland Volunteer Infantry of the Union army and was in active command as colonel of that regiment for 12 months, serving without pay and furnishing his own servants and horses. The regiment took part in 22 engagements over the next three years. Although his constituency was seriously divided about the war, states' rights, and slavery, Webster voted for the abolition of slavery in 1863. In 1881, he became the first president of Harford National Bank.

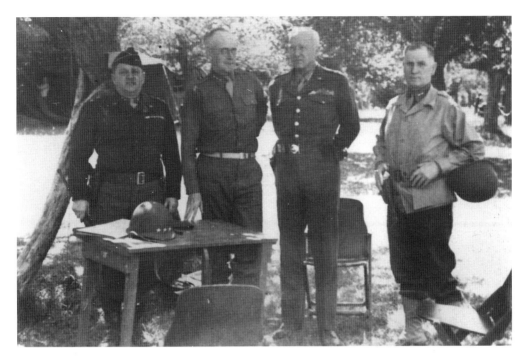

Milton Atchison Reckord

Milton Reckord's great dream was to join the military, but he promised his mother he would wait until he was 21. Therefore, he started his career at the family business, the Reckord Mill, on North Main Street. Once 21, he enlisted in the Maryland National Guard and found his destiny.

He ranked as a major by 1906 and in 1916 was given command of the 2nd Battalion, 1st Maryland Infantry under General Pershing in the Mexican Border War. In 1918, with the rank of colonel, he led his regiment during the Meuse-Argonne offensive in World War I. After the war, Maryland governor Albert Ritchie asked Reckord to serve as adjutant general of the Maryland National Guard, a position he held for almost 45 years.

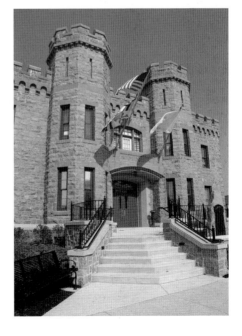

With the start of World War II, Reckord once again found himself in the role of combat leader, but by 1942, he had reached the ceiling age of 63 and was transferred to a stateside position overseeing military and civilian war activities and industrial production. In 1943, General Marshall, Roosevelt's chief of staff, offered him the chance to stay in active service, appointing him theater provost marshal, European Theater of Operations. Even as the conflict ceased, he was tasked with feeding and housing hundreds of thousands of prisoners of war before returning to his home base in Bel Air.

Reckord went on to achieve the rank of lieutenant general and continued to serve as the ranking line officer until his retirement on December 31, 1965, at the age of 86. In recognition of his unequaled service, the state named Bel Air's armory for him. He is pictured above on the far right with (from left to right) Gen. Walton Walker, Gen. Omar Bradley, and Gen. George Patton.

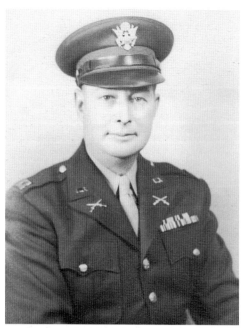

Earle Burkins

A veteran of the Meuse-Argonne offensive, Colonel Burkins served with the 29th Infantry Division. On returning home, he purchased the Blue Moon, a silent movie theater on South Main Street. The theater had a single reel, hand-cranked projector and a live piano player. In 1928, Burkins built a movie palace, the Argonne, at 5 North Main Street that contained 600 seats and a pipe organ. He installed a sound system in 1929. The theater, eventually renamed by subsequent owners as the Bel Air Movie Theater, closed in the 1970s.

In 1941, Burkins again served his country. Promoted to major, he commanded the newly formed State Guard and was responsible for training local patrols and providing emergency response in the absence of the National Guard. Simultaneously, he served as Bel Air's mayor between 1940 and 1946.

H. Merle Bailey

Captain Bailey served in the 446th Bomber Squadron in World War II during the North Africa campaign. He was awarded the Distinguished Flying Cross, a medal awarded only to Armed Forces personnel who distinguished themselves in actual combat by heroism or extraordinary achievement in an aerial flight. He also earned eight additional air medals.

A true hero who gave his life for his country, he was buried in the North Africa American Cemetery in Tunisia. A memorial statue honoring Bailey for his service can be found at Bel Air Memorial Gardens. (Kathi Santora.)

John Adrian Robbins Jr.

World War II raged on in both the Atlantic and Pacific theaters when John Robbins graduated from Bel Air High School and began his college career at Washington College. He was anxious to do his duty and hoped to become a military pilot. After leaving school early and signing up with the Army Air Corps, he was sent to Biloxi, Mississippi, for basic training and then on to Catawba College in Salisbury, North Carolina. He was told on graduation that pilots were no longer needed, and he would be transferred to gunnery school in Laredo, Texas. Finally, his orders came in December 1944, sending him to Suffolk, England, and the 487th Bombardment Group of the 8th Army Air Force.

Assigned to one of the Flying Fortress B-17 bombers, Sergeant Robbins flew his first mission as a ball turret gunner on February 9, 1945. The mission, to bomb Weimar, Germany, was successful, but the plane was hit by German antiaircraft fire, knocking out one engine just after the pilot issued the bombs-away signal. A few minutes later on the return trip, a second engine quit. The plane lost altitude and speed and dropped behind its squadron. Barely past the battle lines in Belgium a third engine quit and the planes propellers windmilled helplessly as their vibrations rocked the plane. The pilot gave the bailout order and four men leaped from the nose of the plane. But Sergeant Robbins and three crew members in the plane's waist were unable to get their escape hatches open or to notify the pilot of their predicament. Meanwhile, pilot Budd Wentz, of Riverside, New Jersey, believed that he was alone in the plane and decided to make a crash landing. He picked a bare patch of farmland and, as the last engine gave out, brought the big bomber down in a freshly plowed field. Sliding along on its belly with the props still churning wildly, the plane soon filled with soft oozing mud. When the Fortress finally came to a halt, Sergeant Robbins found himself safe but covered in mud.

He went on to fly 25 more bombing missions over Germany and returned home in April 1945 to finish his schooling and become a Baltimore City teacher, administrator, and recognized local artist. (US Air Force.)

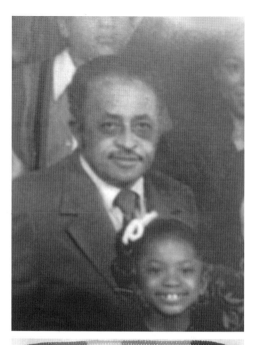

Louis Hickman Sr.

Hickman spent his childhood in Richmond, Virginia, before joining the US Army in 1944. At 19, he found himself heading for the European front with General Patton's army. After serving in both World War II and Korea, Sarge, as he was generally known, returned stateside to serve at Aberdeen Proving Ground as the first African American instructor in the mobility training department of the ordnance center. He retired in 1963, as a master sergeant, but continued to teach as a civilian instructor until 1980.

On the 50th anniversary of the Normandy invasion, French president René Garrec awarded him the Jubilee of Liberty medal. He was also awarded the US Army Certificate of Merit for the European Theater of Operation. (Tracy Roston.)

Clarence Fry

Born in a Pennsylvania coal mining town, Fry (left) served as an Air Force fighter pilot during the Korean War. He earned the Air Medal with two clusters as well as the Distinguished Flying Cross for engaging a night fighter pilot in a Russian/Chinese plane. Based on the delicate politics of the era, he was not allowed to tell anyone of the award for many years.

On returning home, Fry completed his degree in aeronautical engineering and served three years as a test pilot at the Martin Marietta Company. His career eventually brought him to Aberdeen Proving Ground. In 1957, he moved to Bel Air to be close to his job. He continued his community service by volunteering in the town, his church, and wherever he felt needed help.

Ann Stifler Pearce

Immediately after graduating from nursing school at Church Home and Hospital in 1941, Ann Stifler joined the Army Nurse Corps and went to Fort Lee, Virginia, for basic training. Orders soon came to report to New York for transport to North Africa as part of a convoy in General Patton's First Division. The voyage was an adventure in itself, 14 days on the open sea surrounded by troop ships and their escorts. One day outside of port, one of the ship's engines exploded. Stifler's ship limped into port with only a couple of escort ships as the rest of the convoy left them behind.

On arriving in North Africa, nurses were assigned four to a tent. Patients were housed in larger hospital tents, 40 to a tent. The nurses worked long, exhausting hours caring for wounded Allied and enemy soldiers. Food was generally limited to Army rations, but cigarettes could be traded with locals for such delicacies as chicken and tangerines. The Luftwaffe planes attacked regularly. Nurses took cover in the foxholes next to their tents. Luckily for Lieutenant Stifler, on one occasion, she did not reach the foxhole, which was hit with shrapnel.

Once the North Africa Campaign slowed, the troops and nurses moved on to Italy. There, accommodations were somewhat better, with at least some diversions. Nevertheless, the area was not without its dangers. On one trip to obtain morphine, Lieutenant Stifler and the soldier escorting her got lost behind enemy lines and were strafed by enemy fire. After a second incident where she and two other nurses staffed the operating theater in the absence of doctors after a bombing, her commanding officer arranged for her and the two other nurses to meet with Pope Pius XII.

One of Stifler's Italian patients, an artist before the war, became a friend and offered to paint a picture for her. She gave him a photograph of her family's Bel Air home. This patient, a Mr. Terrabochi, who had paraplegia, painted a beautiful representation of her Moore's Mill Road home using his mouth to hold the brushes. (Kathi Santora.)

CHAPTER SEVEN

The Ministers, Educators, and Professionals

It is easy to take for granted Bel Air's sophisticated library system, attractive Victorian structures, award-winning schools, and the many agencies that meet citizens' needs. However, dedicated and talented people often fought hard for these achievements. These are the builders, workers, activists, and professionals who made Bel Air the scenic and prosperous community it is today.

In the early days of the colony, schools were nonexistent. There were few doctors and limited professionals. Those seeking to follow in the professions generally went to Europe for training. It was not until 1768 that the first American medical degree was issued. It went to Dr. John Archer, who lived on Thomas Run Road where he established Medical Hall, a school for future physicians. Archer trained 50 medical students between 1786 and 1810, five of whom were his sons. Another famous summertime resident physician was Dr. Howard Kelly, owner of Liriodendron. He was one of the "Big Four" who founded Johns Hopkins Hospital and introduced many groundbreaking gynecological procedures. His home now serves as a jewel of the county's parks and recreation program. Today, it is a venue for meetings, events, weddings, an art gallery, and an archeological museum organized by Dan Coates, Kelly's great-grandson.

Change has always been difficult, and much of this change was brought about by professional educators, attorneys, and ministers. When C. Milton Wright took over as Harford County's superintendent of education in 1915, the system consisted primarily of one-room and two-room schools. During his 30-year tenure, he upgraded the buildings, staff, and sense of professionalism.

At a time when Bel Air's school system was segregated, Hannah Moore, a local businesswoman, was a major force in Bel Air's African American community. She stressed the importance of education and funded the Bel Air Colored High School. Without her efforts, many African American students would not have had a high school education. In the 1960s, her efforts were aided by the altruistic and heroic efforts of Charles Reed, who helped lead the county school board through the throes of a controversial battle over desegregation.

Dr. John Archer

In 1768, Dr. Archer was the first recipient of a medical degree in America. His route to medicine was circuitous. After graduating from Princeton, he decided to teach. When that did not work out, he considered the ministry but was denied by the Presbytery of New Castle, Delaware. He eventually found his true calling and entered medical school at what is now the University of Pennsylvania.

His practice was highly successful, although his fee was paid in everything from pork to a half-year's rental of the family's church pew. Patients occasionally paid in cash, but there were also many IOUs. In 1775, he began his "patriotic work," voting for the Relief of the Poor in the Town of Boston and the Purchase of Arms and Ammunition for the Defense of Life, Liberties, and Properties. He signed the Bush Declaration, a precursor to the Declaration of Independence, and was a Delegate to the first State Constitutional Convention in 1776. During the Revolutionary War, Dr. Archer worked with his brother-in-law to supply hemp linen for tents for the forces and with Richard Dallam to provide guns and ammunition. He also raised a company of 78 soldiers, mostly his patients, with him as their captain to fight for freedom.

Dr. Archer later trained five of his six sons as doctors at their home, Medical Hall, on Thomas Run Road. The sixth son, Benjamin, became a lawyer, serving as a chief justice of Maryland and in a presidential appointment as judge of the Mississippi Territory with gubernatorial powers. Dr. Archer was elected to Congress in 1800 and 1802, serving his county and his country until the end of his life.

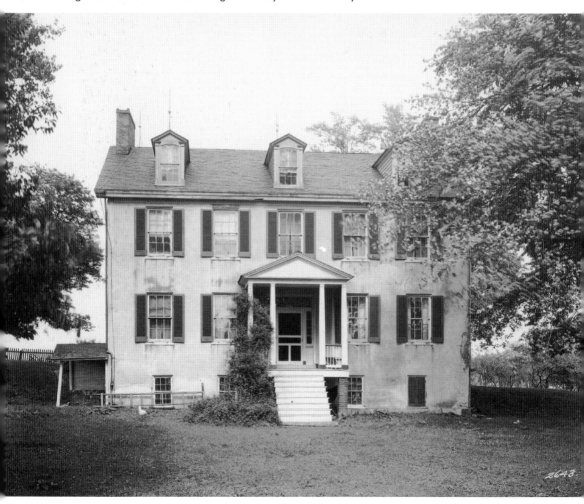

Howard Atwood Kelly

At the turn of the 20th century, doctors focused scant attention on gynecology. Dr. Howard Atwood Kelly, one of the "Big Four" Johns Hopkins Hospital physicians, turned that around. His surgical expertise in gynecology drew colleagues and students to his operating room. A pioneer of radium treatments for cervical cancers, he authored 485 books, pamphlets, and journal articles.

His wife, Laetitia, and their nine children retreated annually from Baltimore City's summer swelter to Liriodendron. The mansion and grounds rocked with children and pets. It also had the county's first in-ground swimming pool.

At 80, Dr. Kelly performed his last surgery. In January 1943, Kelly and his wife died within hours of each other at Baltimore's Union Memorial Hospital. (Alan Mason Chesney Medical Archives.)

Liriodendron

Today, Liriodendron is a community gathering place, known for its cozy wedding venue, local artists' gallery, and a spectacular wisteria-drenched porch in early spring. (Both, Kathi Santora.)

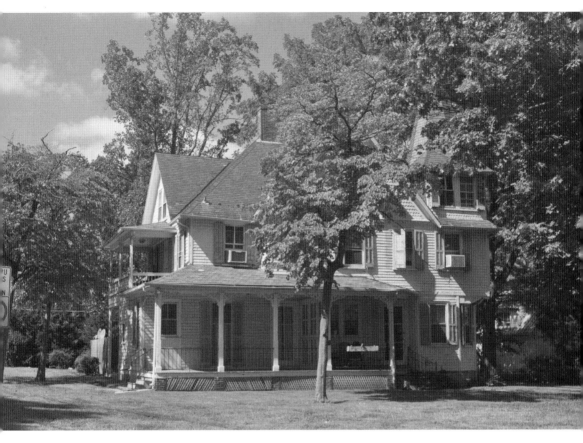

Jacob Bull

Known as Bel Air's master builder, Jacob Bull was a self-taught architect. He is credited with championing Queen Anne Victorian architecture, a style that defined Bel Air through the 1900s. Even today, several beautiful Victorian residences grace Broadway. Such structures once bordered most of Main Street. This Victorian architecture was introduced at the 1876 Centennial Exposition in Philadelphia, Pennsylvania, the first official World's Fair in the United States. Bull saw great potential in the style and constructed his residence at 104 East Broadway as a showcase and model for prospective clients. He was highly successful, and soon most of the new buildings in town had a least some details of this new style.

He left his mark throughout town, building the addition to the Bel Air Academy on Gordon Street and the Masonic Temple on Bond Street as well as numerous other residential and commercial structures. In recognition of Bull's contributions as the town's premiere builder and those of George Archer, the town's leading 19th-century architect, Bel Air presents an annual "Archer-Bull Award" recognizing excellence in architectural design of newly renovated or constructed structures.

Bull died tragically in an 1899 accident. While inspecting an older house for renovation, he fell nine feet through a hole in the floor. He never regained consciousness. (Kathi Santota.)

Helene Augusta Bradshaw Lee

The daughter of an Irish immigrant who fought for the Union, Helene Augusta Bradshaw married a Confederate veteran, Col. Otho Scott Lee, in 1904 at the age of 30. She was a dedicated teacher and later served for 15 years as president of the Harford County Board of Education. At a time when farming responsibilities limited access to education for many, she felt it was important to make books available to all. With this in mind, in 1912, she organized the Harford County Library Association to raise funds to establish a local library.

The group secured two rooms above Bull's Tailor Shop on Main Street. Helene classified 815 volumes and devised a card-charging system before opening to the public. Two long window benches lined the front of the room facing Main Street, separated from the library proper by a counter and grille. The seats provided a reading room that was open all day, but the library remained open only six hours a week.

Within a short time, the library had 250 members, paying dues of 50¢ a year to help maintain and build the collection. Soon the foundation raised $750 along with gift money, books, and furniture, allowing them to increase the collection to 3,000 volumes. In 1918, the library moved across the street to the Bel Air Armory.

Constantly advocating for government-sponsored libraries, Lee was appointed by Gov. Albert Ritchie to the Maryland State Library Commission in 1920. Serving until 1926, she oversaw the beginnings of a statewide library system.

C. Milton Wright

One of Harford County's most distinguished historians, Wright began his career teaching in a one-room school near Madonna Road. After securing his degree in history from Western Maryland College, he accepted a position at the House of Refuge, a reform school for boys in West Baltimore. Assigned 90 boys, Wright taught half-day sessions, then supervised the boys for the remainder of the day. He helped select the first group of 40 boys to be sent to the new Maryland Training School at Loch Raven, choosing boys who he believed would not run away.

In 1907, he came back to Harford County to teach, serving as principal of Aberdeen High. Eight years later, the Harford County Board of Education appointed him superintendent of schools, a post he held for 30 years. At the outset, his major challenge was consolidating Harford's existing one- and two-room schools into a centralized system at a time when transportation was limited to horse and buggy and funds were severely limited. In spite of two world wars and the Depression, he revamped the system and expanded it from 125 to 350 teachers.

After retirement, Wright simultaneously worked for the *Aegis* for seven years; took on the chairmanship of the Harford County Boy Scouts; served as superintendent of the Bel Air Presbyterian Church's Sunday school; and became treasurer of the county library board. In 1952, he took on yet another career as county director of probation. For the next 10 years, he counseled delinquent boys, collected thousands of dollars in back child support, and even did some marriage counseling.

At 84, Wright again retired, this time to write *Our Harford Heritage,* which remains the most accurate, complete, and invaluable reference book on local county history written to date.

Hannah Moore

The fact that Hannah Moore was a business owner, landlord, community icon and education trailblazer in the early 20th century was all the more remarkable because she was an African American woman with a grade school education.

Hannah and Stephen Moore Sr. owned a general store on Bond Street (roughly where Courtland Hardware is now located) at a time when Bel Air's African Americans had few shopping options. The store was such a fundamental piece of the community that it may not have had a formal name. Later, seeing that neighbors had few places to socialize outside of home and church, the couple built an adjacent restaurant that came to be known as Hannah Moore's Beer Garden or, to regulars, "the Place."

Hannah was a formidable force, says her grandson Stephen Moore III, who recalls her as savvy, smart, gruff, generous, and hardworking. Few knew that she quietly stashed away a good portion of her profits. This was likely without the knowledge of her husband, who owned and bet on racehorses, a rare and expensive hobby for an African American man of those times. Hannah understood that both land ownership and education were keys to a sound future. She purchased land and properties surrounding her businesses. Concerned that African American children had no educational options after eighth grade, she approached school superintendent C. Milton Wright with an offer: she would donate land to start the Bel Air Colored High School. The Rosenwald Fund, a national philanthropic group dedicated to furthering education for African American, matched her donation. Today, the Historic Bel Air Colored High School, dedicated to Hannah Moore, remains at 205 Hays Street.

All of Hannah and Stephen Moore's six children attended higher education and pursued professional careers. With little fanfare, Hannah left a remarkable legacy that exists to this day among her own descendants as well as those of her Bond Street–area neighbors and customers. (Kathi Santora.)

Melvin Turner

At 85, Melvin Turner reluctantly retired from his last job as a parking lot attendant at the First National Bank on Main Street.

Turner was born north of Hickory in 1910, when African Americans faced limited educational and job opportunities. He left school after eighth grade since Harford County offered no high school education to African Americans. His penchant for hard work, however, took him on many paths. As a teen, while his family briefly lived in Philadelphia, he recalls getting up early and walking to the legendary Merion Cricket Club to caddy for Bobby Jones. Back in Bel Air in the 1930s, Howard O'Neill, a Farmers & Merchants Bank president, employed him for 10 years as a butler, chauffer, and handyman. (The O'Neill house is currently the site of the Mann House, an addiction recovery facility on Williams Street.) He then spent 23 years as a boiler operator for E. Tolzman & Sons and another 30 at the Edgewood Arsenal. Turner still lived in his longtime home on Alice Anne Street when he passed away at the age of 103.

Charles H. Reed, Esquire

After serving in the US Navy in the Pacific in World War II, Reed returned home to Bel Air with his New York bride and completed his law degree. His view of the world was forever changed by his war experiences, and he vowed to do whatever he could to prevent another war. He became an effective and lifelong peace advocate.

Reed opened a law practice with his childhood friend Albert Close, eventually expanding the practice to include Broadnax Cameron. Reed was noted for his high principles of equality and brotherhood. He did a tremendous amount of pro bono work and never sought the limelight, always seeking to do the right thing even when it was highly unpopular. He served as president of the Maryland Attorney Grievance Commission and as a trustee for Harford Community College, being credited with determining the location of the campus.

As president of the Harford County Board of Education, it was his task to desegregate county schools. For him, this was an obvious necessity, but it was seen throughout the county as unacceptable, and to some, it was noted to be a "communist plot." He and his family were harassed, and some felt that his civil rights advocacy cost him a judgeship.

A man born before his time, he worked tirelessly toward world peace, founding the Harford County Chapter of the United World Federalists and the local Unitarian Universalist Church. He biked to work every day, encouraging people to forego their automobiles long before environmentalists became active.

In 1990, his Princeton classmates honored him with the Distinguished Service Award, noting that "Reed exemplifies the Wilsonian and Princetonian ideals of selfless service to one's fellow man." (Susan Walls.)

Thomas Carroll Brown, Esquire

The consummate gentleman, T. Carroll Brown was the eighth generation of his family to live and work in Harford County. After serving in the US Navy during World War II, Brown returned home and established a career with Commercial Credit, Inc. When his father died, his brother Freeborn asked for his help in continuing the family's law practice. Carroll agreed to enter University of Maryland Law School and joined the firm in 1954, continuing as a partner for the next 49 years.

This much beloved and well-respected man, became an icon in the county legal community. Local government officials and his many clients and friends routinely sought his opinions and assistance. His elegant and impeccable manners and gentle Old World style worked wonders with even the most recalcitrant opponents, turning contentious situations into friendly discussions and generally achieving the results he desired.

Carroll's legal practice concentrated in the fields of real estate, zoning, land use, estate planning, wills, and trusts. Many of the most successful lawyers and judges in Bel Air entered their profession under his tutelage, assuring that his legacy will continue for many years to come. (A. Jay Young.)

Dennis Schultz

For 38 years, US postal carrier Dennis Schultz was one constant amid downtown's daily street kaleidoscope of office workers, shoppers, and jury pool prospects.

Schultz bantered about sports, weather, his pets, and news of the day at each of his 320 stops. He quietly gave money to homeless people, provided stamps to those in need, and visited customers in the hospital. Regulars wished Shultz well on his last route before retirement in January 2015. (Kathi Santora.)

Charles Lee Robbins

Few would associate the term consummate entertainer and raconteur with a history teacher, but Charles Robbins is all three and more. Born in West Virginia, his family moved to Bel Air in 1935. From an early age, he was recognized in the local paper, the *Aegis,* as the Robbins family's "interesting son."

At 17, just out of high school, he joined the US Army and was posted to the Aleutian Islands in the final months of World War II. On returning home, he began his college career, only to reenlist in 1951 at the outbreak of the Korean War. After a monthlong sea journey, Robbins found himself on the front lines. His unit came under regular attack, and he received a serious head wound for which he holds the Purple Heart. Rejecting a medical leave, he returned to his unit and served his full tour.

After completing his service, Robbins returned home to continue his education, married, and raised four children with his wife, Ann, at their home on Rockspring Avenue. To support his growing family, he worked at the Bel Air Post Office and taught school. His classes became legendary, both for his amazing knowledge, particularly of local history, and his entertaining presentations. A natural, commanding speaking voice combined with a quirky sense of humor made his lectures unforgettable, and soon brought invitations for speaking engagements throughout the county.

Robbins's interest in nature, hunting, fishing, and photography led to a series of books and articles about Harford County. One of his most popular books was *R. Madison Mitchell: His Life and Decoys,* a story of the celebrated Havre de Grace decoy carver and funeral director. (Charles Robbins.)

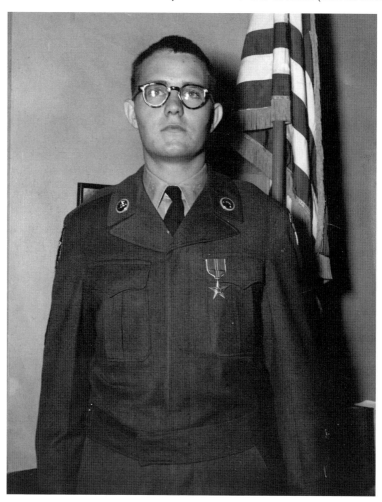

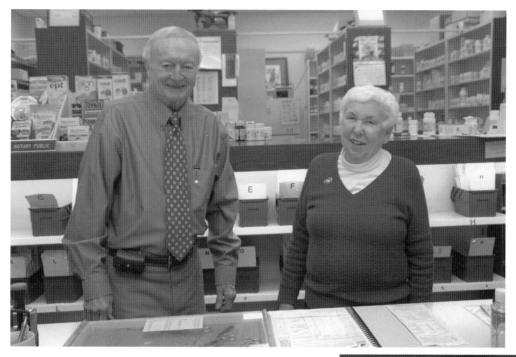

Eugene and Marytherese Streett

Bel Air's Main Street in the 1960s and 1970s was so busy that Boyd & Fulford Drugstore owners Marytherese and Gene Streett hired an employee just to sell Timex watches. The store opened in 1892, when Bel Air was largely a summer resort for city-dwellers and a shopping mecca for farmers and farmhands. Years later, as a 14-year-old employee, Eugene Streett shaved ice and swept the floor. After completing pharmacy school, he returned. Marytherese was a Bel Air High School teacher who had moved from Pennsylvania. One day, she sat down at the soda fountain and was introduced to the pharmacist. The couple married and, later, purchased the business in 1963. The store has thrived through ever-changing pharmaceutical trends, a generation or two of customers, a 1972 fire, and two Main Street renovations. Though Marytherese passed away in 2012, Dr. Streett continues as a Main Street pillar. (Kathi Santora.)

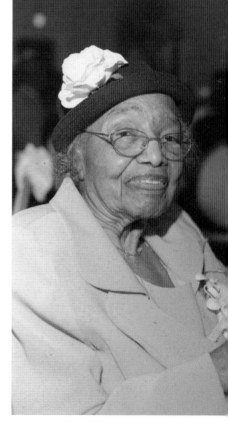

Mazie Taylor

Mazie Taylor was a teacher at the all–African American Central Consolidated School in Hickory in 1964. She understood that school desegregation would profoundly change her students' lives. Soon after the Harford County Public School System included her on a pioneering team to implement the new desegregation laws, she founded Black Youth in Action (BYA), which was designed to provide leadership training and civic awareness. BYA continues its work to this day, including its trademark event, the annual debutante ball, which caps a year of philanthropic, cultural, and social training. (Toni Dorsey.)

Richard Oliver Cook

Known throughout Harford County for his wildlife rehabilitation and veterinary practice, Dr. Cook's impact on agriculture and recreation programs is unprecedented. He graduated from the University of Pennsylvania Veterinary program before coming to work first at Jarrettsville Veterinary Center and, later, at the Bel Air office of Dr. Rutledge, which he later purchased.

A specialist in large animals, mainly horse and cattle, he routinely cared for horses at the Bel Air Racetrack on Baltimore Pike until its demise in the 1960s and treated the horses of local horse breeders like the Pons family and Alan and Audrey Murray. His love of horses and riding led him to work with several local riding clubs in organizing the Harford County Riding Clubs, Inc. The group met once a month at his clinic's waiting room and developed plans to build and maintain riding trails throughout the county. They eventually obtained permission from several farmers to cross their land, clear trails, and develop a 50-mile adult trail and a 25-mile trail for kids. When the almshouse on Tollgate Road closed in the 1960s, Dr. Cook and other riding club members approached county commissioners requesting that they set aside the abandoned land for an equestrian center to showcase the county's rural roots. The group raised funds and provided labor to plan and build the Harford County Equestrian Center, now an integral part of the county park system.

Meanwhile, Dr. Cook worked closely with the local 4-H Club on their annual farm fair. Lamenting the loss of the old county fair that ceased with the sale of the Bel Air Racetrack and the limited space available for the 4-H Fair at Rocks State Park, he convinced county officials and the 4-H Club to move the fair to the Harford County Equestrian Center. Since 1983, the Harford County Farm Fair has attracted thousands each summer to enjoy tractor pulls, a rodeo, pony rides, and traditional 4-H events.

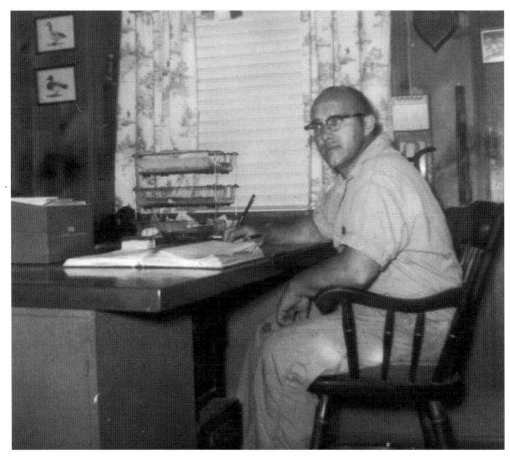

Rev. Gregory Rapisarda

A father of four and recent widower, Gregory Rapisarda made a momentous decision in 2009. He decided to follow his youngest son, John, into the priesthood. A zoning and land use lawyer for many years, Rapisarda also served as county attorney and, later, as attorney for the City of Aberdeen. After his wife Carol's cancer diagnosis, he concentrated more on elder care and estate law, spending as much time as possible with his wife. In 2003, with her encouragement, he was ordained a deacon in the Catholic Church, serving at Saint Margaret's parish while still maintaining his law practice.

Carol died in 2006, and Greg's life turned upside down. Son John was studying for his ordination, which took place in 2008. Greg found himself more involved with the Diaconate and was eventually approached by Archbishop O'Brien, who suggested that he might consider entering the priesthood. After overcoming his initial fears, he sold his condo and moved to St. Mary's Seminary to complete his preparation for the priesthood at age 62.

In 2010, Archbishop O'Brien ordained Deacon Rapisarda to the priesthood. His son, Father John, performed the vestry honors. For the first time in the 221-year history of the Archdiocese of Baltimore, a father and son are serving as parish priests. Father Greg now serves as associate pastor of Sacred Heart of Mary in Baltimore and is a chaplain at Johns Hopkins Bayview Medical Center, where he assists with end-of-life care. (Catholic Review Media.)

Ray and Esther Dombrowski

The Bel Air High School Band had a sound and sight of its own under the leadership of Ray and Esther Dombrowski. Ray was the band director. Esther, though officially the school librarian, led the band front of majorettes, baton twirlers, and pom-pom girls.

Ray and Esther Dombrowski were inducted together into the Harford County Public School Hall of Fame on June 25, 2002. Esther served as Bel Air High School's librarian for 31 years, and Ray was Bel Air High School's instrumental music teacher and band director for 32 years. Together, they shared their unique talents and personalities while creating an enduring legacy.

Ray arrived at a brand-new Bel Air High School in 1953, after already building a musical repertoire at his alma mater, Penn State, and in the US Army Band. Soon, the Bel Air Bobcat Marching Band became a formidable force. 180 musicians and a 60-member band front performed at athletic events, festivals, patriotic occasions, and regional parades. They represented Maryland at the 1976 Bicentennial Parade in Philadelphia. Alumni say there was no A or B team; Dombrowski nurtured any student with an interest in music.

Esther graduated from Bel Air High School in 1948, left to earn library of science degrees. At 20 years old, she returned to Bel Air High School, this time as the school librarian. When she married the band director and began to help design halftime shows and oversee the twirlers and pom-pom team, the Bel Air Marching Band took on an even more celebrated status. After 31 years, Esther retired and worked for the *Aegis*, where she organized archives and wrote for special editions of the paper.

In 2006, Phyllis Fowler, a 1979 alumni, organized a Bel Air Bobcat Marching Band revival. Former band members and students from 30 states came to play in the band or cheer from the audience and pay tribute to a couple they say inspired them for life.

Wendell Baxter

Wendell Baxter joined the Bel Air Police Department (BAPD) in November 1971 after a stint with the Air Force Military Police. He believes that he was the first African American officer on the force.

Baxter's community service extended well beyond the BAPD. He volunteered at the fire department and on the Red Cross Disaster Team. Always the go-to person when disaster struck, he spent innumerable hours assisting the injured, locating shelter for displaced families, and caring for victims. He was on site for the 1987 Amtrak train crash in Chase, numerous apartment fires, and many other local disasters.

Time spent with Bel Air's youth is, however, his fondest memory. Today, many of those who had minor scrapes with the law are the town's lawyers, doctors, and teachers, partly due to Sergeant Baxter's intervention. (Kathi Santora.)

Melynda Velez

Melynda Velez (third from left) believes that starting a nonprofit that helps non-English speakers become a part of the Harford County community was simply what she was born to do. How else to explain how LASOS, Inc., (Linking All So Others Succeed), a germ of an idea in March 2009, has already changed the lives of so many?

Melynda, who speaks fluent Spanish, started her advocacy on an informal, as-needed basis. She soon became the go-to woman for people learning their way around their new community, serving as translator, teacher, tutor, and more.

Believing that a brick-and-mortar location was the key to effective advocacy, Velez purchased a building on Courtland Street. She directs the rapidly growing organization while still working as a Harford County public school teacher. Lasos now offers classes in adult literacy, civics, finance, technology, and citizenship. Volunteers mentor at-risk youth, and there is a growing summer camp. The organization provides onsite translation services, as well as information and referral help, and coordinates the Celebration of Cultures event held at the Bel Air Armory each spring. Velez's timeless advice is simple: "Take the time to see people for who they are and not where they come from." (Kathi Santora.)

CHAPTER EIGHT

The Sports Stars

For many years, traditional farming practices allowed little time for sports or other leisure. The horse was the primary means of travel, and dirt roads were often difficult and dangerous. Bel Air Racetrack provided the major sporting venue. Opening in 1870, the three-quarter-mile track attracted crowds from up and down the East Coast. Racehorses ranged from local nags to Thoroughbreds. The track fostered a strong local interest in breeding and training horses. Cigar, a champion, was born at nearby Country Life Farm, owned by the Pons family. Horse racing's Hall of Fame trainer Buddy Delp developed his lifelong love of horse racing at his stepfather's farm.

In the 1940s, soldiers from across the country congregated at nearby Aberdeen Proving Ground, Bainbridge Naval Station, and Edgewood Arsenal. Several were accomplished boxers. To showcase this talent and provide entertainment for the soldiers and the community, boxing matches were held regularly at the armory and in the basement of the Argonne Theater. One of the stars, local boxer Warrenell "Boom Boom" Lester, went on to become a state champion.

For many years, semiprofessional baseball games were played regularly at the ballfield on Gordon Street where Bel Air Elementary school now stands. These games brought players and spectators from across the county, including Cal Ripken Sr. and John Schafer. Several locals found stardom in the fields of football, baseball, lacrosse, and soccer. Perhaps the most famous was Larry MacPhail, owner of the New York Yankees. Although not originally from Bel Air, he moved here in the 1940s to start a cattle and horse breeding farm. He became president of the Bowie Racetrack, only to be banned from attending races at the track for controversial behavior.

Sports, here as elsewhere, generated excitement, highs and lows, as well as entertainment and fascinating stories behind the games and the players. Bel Air High School coach Al Cesky led his teams to three fabled undefeated seasons. More importantly, he inspired a generation of young athletes to excel in life.

Warrenell "Boom Boom" Lester

His childhood friends called him "Booty" though no one knows quite why. Lester showed promise on the track and field at Central Consolidated School in Hickory. Once, after a childhood bully landed an unexpected punch, he began to frequent boxing gyms in Havre de Grace and Baltimore. Soon, his new nickname was "Boom Boom" out of respect for how his right hand connected to a punching bag.

In 1952, Lester enlisted in the Army, where he was assigned to a special services boxing team. Along the way, he won many matches against opponents from each of the other service branches. After discharge, he triumphed in 112 amateur fights as well as 32 heavyweight and lightweight contests. He retired in the early 1960s and started another career at Aberdeen Proving Ground as a forklift operator. The Maryland Boxing Hall of Fame inducted him in 1981. Locals also remember Boom Boom for the informal gym that he set up in Hannah Moore's Beer Garden on Bond Street. Anyone of any age was welcome to stop by, work out, and get advice from a champ.

Leland "Larry" Standford MacPhail

A soldier, lawyer, businessman, baseball impresario, cattle breeder, and racing stable proprietor, MacPhail seemed capable of doing anything he set his mind to. Rising to the rank of captain in World War I, he commanded an artillery battery in France. Later in World War II, he served as a full colonel assigned as assistant to Undersecretary of War Robert Patterson.

On returning home in 1918, he studied law at Georgetown University. He became an effective trial lawyer, recognized for his flaming red hair, quick mind, and lung power. He possessed a gift for nonstop oratory, as well as a very colorful and flamboyant personality. He seemed destined for a long-term legal career, but MacPhail was restless and turned his hobby of refereeing football games into a career. He was respected for his fearless decisions in the face of sometimes disgruntled, hostile crowds, and began refereeing games coast to coast. His team of officials devised the penalty signals still used today.

In the 1930s, he moved on to baseball, purchasing a Columbus, Ohio, club and, later, selling it to the St. Louis Cardinals with the caveat that he stay on as president. He later owned/managed the Cincinnati Reds, the Brooklyn Dodgers, and the New York Yankees, introducing major innovations, such as air travel for the clubs, radio broadcast of a team's full season, night baseball in the major leagues, and pregame entertainment.

In 1940, he turned to farming. After searching from Connecticut to Virginia, he decided on a 400-acre property just outside of Bel Air. Glenangus was within commuting distance of his baseball team in New York and boasted beautiful terrain with running springs in every field. Initially, he sent representatives to Scotland to purchase an outstanding purebred Angus bull and 15 good females. He expanded the herd each year but determined that he needed to add Thoroughbred horses to be economically successful. With the herd established, his attention shifted to racehorses and breeding operations.

He retired from baseball in 1947 and took on the farm operation full time, serving as a controversial president of the Bowie Racetrack and becoming a highly successful breeder and frequent part of the national and local racetrack scene. In 1978, he was inducted into the Baseball Hall of Fame. (The National Baseball Hall of Fame and Museum.)

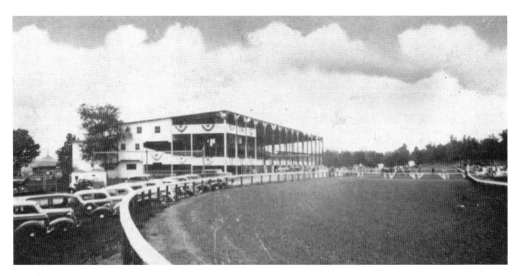

Bel Air Racetrack
The 100-acre Bel Air Racetrack contained a three-quarter-mile track and spacious grandstands. It closed in 1960, and the property is now the site of the Harford Mall.

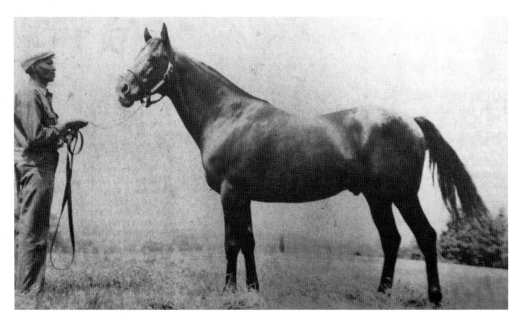

Joshua Eugene Fischer Jr.
Considered one of the foremost African American grooms in Harford County, Fischer loved horses and worked with them for 40 years at the local racetracks and county farms. Fischer worked at Country Life Farm in Bel Air for 17 of those years caring for several prize-winning horses including Saggy, a horse known for beating Triple Crown winner Citation on April 12, 1948, at the Graw in Havre de Grace.

Fischer was also a talented handyman, fixing bicycles and lawn movers in his spare time. Neighborhood children knew they could always count on him to care for their bike mishaps. (Pons family.)

Grover Greer "Buddy" Delp

Delp's father died in a drowning accident at a family reunion when Buddy was just two. His mother eventually remarried Raymond Archer, a renowned Thoroughbred horse trainer who is credited with teaching Delp about training horses and inspiring him toward his award-winning career.

His most famous horse was Spectacular Bid. Delp considered Bid "the greatest horse to ever look through a bridle." Bid won the Kentucky Derby and the Preakness and was a favorite to win the Triple Crown until injured by a safety pin that stuck in his hoof just before the race at Saratoga. He faded in the final eighth of a mile and finished third.

Delp received the Eclipse Award as the nation's leading trainer in 1980 and was inducted into the National Museum of Racing Hall of Fame in 1982. (Monmouth Meadows.)

Cigar

One of the world's most memorable Thoroughbred horse champions arrived in the world on April 19, 1990, at the Pons family's Country Life Farm, a bucolic breeding facility located just out of sight from Route 1's throng of car dealerships. His name, Cigar, was a curious one, even in horse racing. Owner Allen Paulsen, founder of Gulfstream Aeronautics and a pilot, named the colt after a Gulf of Mexico aviation checkpoint.

Cigar won 16 consecutive races, a record unmatched since Triple Crown winner Citation did so. One win was during an international card at the 1996 Dubai World Cup. In his career, Cigar earned close to $10 million, then an unmatched sum. A simple wreath of greens, a black ribbon, and several roses adorned the entrance to Country Life Farm when Cigar died in October 2014. (Ellen Pons.)

Al Cesky

Former players of Bel Air High School football coach Al Cesky in the 1950s and 1960s still stop in their tracks at the mention of their coach, idol, and mentor. These men, now closing in on retirement, say that Cesky did not just shape them into better high school football players than they might have been, but he also taught them how to succeed in life. Some say that Cesky's former players make up a surprisingly large portion of Bel Air's Who's Who.

Cesky led the Bel Air Bobcats to three undefeated seasons in 1955, 1959, and 1965. They remain the only undefeated seasons in the school's history. Observers trace Cesky's game philosophy to the year that he spent at the University of Maryland, playing under legendary coach Bear Bryant.

"Al Cesky believed in practice, exuded personal integrity and demanded it of the players," recalls a current community leader who played on one of the undefeated teams. Cesky met with his team in the off-season, helped them in college searches, and insisted on weekend community service. In classic small-town form, he heard about youthful transgressions and was quick to provide a lecture or even suspension from playing if warranted.

He retired in 1965, after his third undefeated season. Soon after his sudden death in 1985, former students formed the Al Cesky Scholarship Fund, which continues to provide scholarships to promising young men and women.

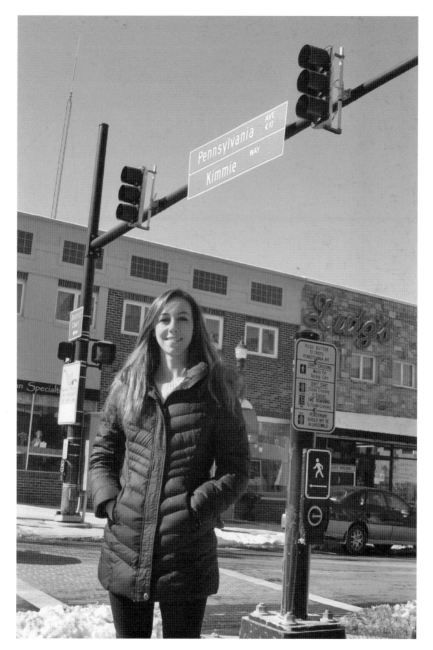

Kimmie Meissner

At 15, ice-skating champion Kimmie Meissner was the youngest American athlete to compete in the 2006 Olympics in Turin. When national and international sportscasters mentioned her hometown, neighbors, friends, and Fallston High School classmates stood a little prouder.

She finished sixth in the Olympics, reason enough for thousands to line Bel Air's Main Street for a welcome-home parade. To cap off the day, a portion of Pennsylvania Avenue between Main Street and Hickory Avenue was renamed "Kimmie Way." Close to a decade later, she still marvels at the memory.

She traces her competitive spirit to her grandmother. "We still play jacks. It's like a battle. She's 91 now and it's still intense. I think my sense of competition came from her." (Kathi Santora.)

Jay Witasick

For Jay Witasick, baseball was always all about the pitching. He said, "Nothing happens until the pitcher throws the ball. I wanted to be that guy and not stand in the field and watch other people play." Witasick, who spent childhood years playing ball in the alleys behind his Parkville row house and in local leagues, arrived at C. Milton Wright high school in 1988 as the new kid on the Mustangs. He credits coaches Jim Miller and Jim Fieldhouse for guiding him to success, both on and off the field. He debuted in the majors on July 7, 1996, pitching for the Oakland Athletics, and went on to play for seven teams until 2007. He currently works as a sports agent for the Warner Companies and lives in Bel Air. (tPoz Photography.)

Pat Healey

Baltimore Blast defender Pat Healey set out early to be a professional soccer player. First stop for the St. Margaret School alumni was the Bel Air Recreation Council's four-to-five-year-old team. In fact, Healey has a fondness for home teams. He was Calvert Hall's 2003 High School Player of the Year as well as the eighth-leading scorer at Towson University before joining the Blast in 2008. Healey, who briefly considered a baseball career, was no doubt validated when he was named 2009 National Indoor Soccer League (NISL) Rookie of the Year after scoring 16 points in 18 games.

Healey lives in Harford County and makes frequent community appearances at schools, festivals, and youth sporting events. (David Rippeto.)

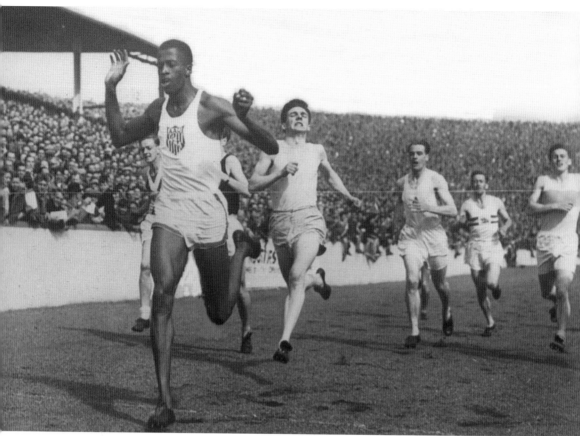

Bill Brown

Though he was a natural track athlete, Bill Brown did not realize his potential until his early twenties. In the 1940s, his alma mater, Central Consolidated High School, lacked the modern gym and groomed athletic fields found at the all-white schools. In the US Army and on a whim, he began to compete in meets and found that he outran most of his competitors. After discharge, he attended Morgan State and competed on an international basis, medaling in the first Pan Am Games in 1951. Brown returned to Bel Air and became the athletic coach at Central Consolidated for 15 years. When schools finally desegregated in 1965, he transferred to Bel Air High School. He was part of the coaching team that led the Bel Air Bobcats' legendary three undefeated football seasons. (Above, Bill Brown; right, Kathi Santora.)

CHAPTER NINE

The Heroes, Villains, and Ne'er-Do-Wells

There is always a tendency to brag about one's hometown heroes. However, there is also the other side of the story, the few who are actually villains and mischief-makers. Bel Air has many heroes; a few like Frank Bateman, George Noonan, and Walt Holloway are described here. These individuals rarely receive their truly deserved recognition. On the other hand, Bel Air's most famous villain, John Wilkes Booth, is the subject of numerous books, plays, and stories. In truth, all of the people featured here are more than the single act that brought them to the public's attention.

Over the years, the community has experienced both good and bad times, and its citizens always stepped forward to care for one another. Whether dealing with financial crises, wars, civil unrest, personal tragedies, or daily needs, Bel Air's residents worked together to meet community needs and survive, some better than others. Certainly, the Civil War was a pivotal point in Bel Air's history as it was in the nation. Living in a slave-owning state, many locals like Herman Stump strongly resisted the Federal position, while others like Alfred Hilton and Charles Phelps fought bravely to uphold the Union. While wars tested the philosophy of many locals, the passions and prejudices of area citizens also played out in local events. Nevertheless, these were offset by the bravery and kindness of Bel Air's heroes.

Herman Stump

A pro-secessionist, Stump was a leader in the Knights of the Golden Circle, a secret Texas-based organization that sought to create a confederation of slave holding states. Stump fled to Canada to escape arrest for aiding the enemy in 1861. Through family connections, he was able to return in 1862 and, later, became a noted lawyer, state senator, and congressman.

He coauthored the Immigration Act of 1891 prohibiting certain classes of immigrants from entering the United States. The act also led to selection of Ellis Island as the main point of entry for immigrants from Europe and the requirement for medical examinations before entering the country. In 1892, he coauthored the Chinese Exclusion Act, which banned all Chinese immigration. After leaving Congress, he became the first commissioner of immigration, a position created by the legislation he coauthored.

George Oliver Noonan

A group of rowdies was making life miserable for Bel Air's quieter citizens, so the town officer Bailiff Noonan prepared to crack down. The officer confronted the rowdies on Saturday, June 26, 1920. When he warned them to stop igniting firecrackers, someone lit the fuse on one and dashed it down at his feet. He divested some of the boys of their fireworks, placing them in his pocket. But at least one of the revelers was not happy with that, so Bailiff Noonan arrested Billie Trundle. Trundle resisted, and in the scuffle, the officer was either tripped or thrown heavily to the ground, causing the firecrackers to explode. His clothing was torn to shreds, and the officer was seriously burned and bruised. He was 34 years of age and died two days later from his injuries. (Kathi Santora.)

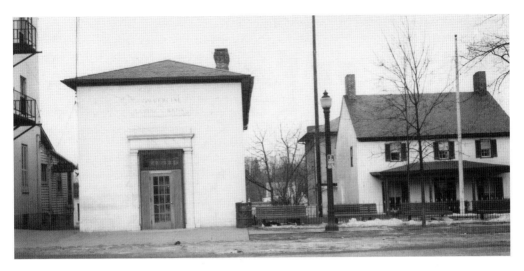

Frank Bateman

Deputy Sheriff Bateman was a man of large proportions with nerve and courage equal to his size. On June 10, 1899, he was called to a house on Alice Anne Street where he found John Hays, who was dangerously out of control after a lengthy drinking spree. On arrival, Bateman rapped and called to Hays to open the door. When Hays refused, he read him the warrant aloud, to which Hays answered, "I'll kill you if you don't go away."

The deputy sent a young boy for an axe from a nearby house to break down the door. Hays then opened the door and fired twice at Bateman. Although mortally wounded, Bateman returned fire and killed Hays, who fell first with the deputy falling on top of him. Deputy Bateman was the first officer killed in the line of duty in the county. The sheriff's house and jail are shown on the left above.

Walter Holloway

When volunteer firefighter Walter Holloway arrived at the October 1998 fire in the apartments above Main Street's Country Gourmet Restaurant, he had enough experience to know where people trapped by fires tend to hide. An unaccounted-for 66-year-old female resident was somewhere in the smoke and flames. He hoisted an air pack and headed in. He checked the edges of the first apartment, under the beds, and in the closets.

Smoke made visibility zero. He dropped to his hands and knees. Finally, he located the bathtub with the unconscious woman inside. Fellow first responders Scott Panowitz and Skip Strong met him on the stairs. The three carried her to safety.

These days Holloway, a history aficionado and Ma and Pa Railroad expert, can be found at the Harford Historical Society where, with the aid of a virtual photographic memory, he assists researchers and preserves county historical treasures. (Kathi Santora.)

Tudor Hall

The Booth family's Tudor Hall (pictured below), an essential destination for any aficionado of American history, lies just outside of Bel Air. John Wilkes Booth is said to have rehearsed on his bedroom balcony. (Jerrye and Roy Klotz, MD.)

John Wilkes Booth

For better or worse, Bel Air shaped the man that John Wilkes Booth was to become. Booth was born in a log cabin on his family's farm, a 150-acre property located three miles northeast of town. His father, Junius, was a renowned, though mercurial, stage actor. His mother, Mary Anne, was Junius's English-born, common-law wife. As the couple's 10 children grew, their parents encouraged the brood to develop their imaginations and express emotions freely.

Eventually, Junius commissioned a one-and-a-half-story Gothic Revival cottage for his growing family and named it Tudor Hall. Before its completion, Junius died while on a theater road tour. Along with Mary Anne and several siblings, however, John spent his teenage years there, often acting out Shakespearean scenes from his bedroom balcony.

As a border state during the Civil War, Maryland had its share of loyalty-divided families, including the Booths. Older son Edwin, also an actor, was a fierce Union loyalist. In contrast, John reportedly engaged in skirmishes against local Union troops that camped around Tudor Hall.

His Confederate loyalties led him to associate with fervent rebel causes and, eventually, to become the infamous assassin of Abraham Lincoln. The King family, Tudor Hall's tenants after Mary Anne moved from Bel Air, were on hand when soldiers arrived to search for the long-gone John Wilkes Booth. By all accounts a singularly handsome and charismatic man, Booth could have followed the family legacy into theater. Instead, he became a national villain for the ages.

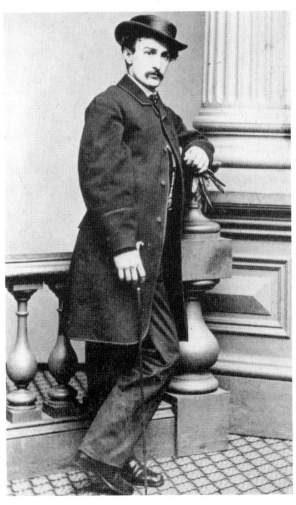

Arthur Preston

Preston and his girlfriend Mary Dorsey lived together in a small house on Baltimore Pike. He had a reputation for beating her and had threatened her life several times. On Wednesday morning, April 12, 1882, he rushed into the jail on Main Street announcing that he wanted to go to jail. Both the sheriff and his deputy were out on business, so the sheriff's son let him go back to the cell, assuming he wanted to look at it, but instead Preston slammed the door and said, "I want to be locked up so no one can get me." Meanwhile, one of the neighbors informed authorities that she believed someone had been murdered. When they arrived at Preston's house, they found the body of Mary Dorsey, who had been killed by a blow to the head.

A crowd formed outside the jail threatening a lynching. With tempers running high, the trial was moved to Towson, and after 10 minutes of deliberation the jury found Preston guilty and sentenced him to hang. The sheriff then began preparation for the execution. A scaffold was erected on the northwest side of the jail in Bel Air with a platform eight feet from the ground. Once the scaffolding was completed, the required 20 witnesses, the local physicians, and press representatives accompanied the sheriff's deputies into the gated area where the sheriff proceeded to carry out the sentence.

Although several physicians requested the body, the sheriff refused and buried Preston at the Hendon's Hill graveyard on Vale Road as he wished. (Kathi Santora.)

Prisoners of War

In 1944, the federal government instituted a prisoner of war camp at Edgewood Arsenal to alleviate the critical labor situation on the arsenal and on area farms. The camp initially housed 50 prisoners, most from the North Africa campaign. By the war's end, there were up to 750 Axis prisoners of war, a small portion of the 425,871 prisoners housed in the 65 camps across the United States.

Edgewood Arsenal was one of Maryland's 19 POW camps. Unlike the Hollywood depiction of these camps, prisoners were required to work, but the amount of work and conditions were specified by the Geneva Convention. Officers could not be compelled to work, and noncommissioned officers could only supervise. Soldiers worked a maximum of 10 hours a day with an hour for lunch. Farmers could not abuse the prisoners and had to provide transportation. One local Bel Air boy, 14 at the time, told of driving a truck load of prisoners each weekday throughout the summer of 1945, recalling that the men worked very hard but kept to themselves.

Farms lined the road from Edgewood to Bel Air in the 1940s, and all were in dire need of workers. The German and Italian prisoners were separated to minimize conflicts. Italian prisoners received privileges not available to the Germans since they were considered cobelligerents as long as they disavowed fascism. This included entertainment and visits from local members of the Italian American Association.

The Army provided guards to watch over the prisoners. The average farmer paid $3 or $4 per day for each worker, which covered the government's cost for food and housing. The prisoners were given 80¢ a day in script that could be used on base. Cash was not used to avoid the potential for bribing guards. At the end of the war, the script was presented to authorities in return for cash.

The prisoners' labor was critical to the local farmers and canners. Without these workers, the 1945 crop would have been lost.

Alfred Hilton and Charles E. Phelps

Alfred Hilton was one of only two Harford-connected Civil War soldiers to receive the Medal of Honor. They could not have come from more diverse backgrounds. Alfred Hilton, born free on his family's Gravel Hill Road farm, lived there until he enlisted in Company H, 4th US Colored Troops in August 1863. Both of his parents had been slaves.

Sergeant Hilton was mortally wounded in September 1864 at the Battle of New Market Heights, near Richmond. When enemy fire shattered his leg, he was carrying the American flag as part of the unit's color guard. While calling out "Boys, save the colors," he handed the flag to fellow soldiers before it touched the ground. Sergeant Hilton died of his wounds a month later in a segregated hospital.

Charles Phelps, from a prominent Baltimore family, joined the Maryland 7th Infantry Regiment, since several of his Bel Air friends, including Col. Edwin H. Webster and Maj. William H. Dallam, were members of that heavily Harford County unit.

While leading a charge at Laurel Hill at the outset of the Battle of Spotsylvania, Phelps was wounded and taken prisoner. He escaped and returned to battle. Colonel Phelps later represented Bel Air when elected as congressman from the 3rd District of Maryland to the 39th Congress and 40th Congress. (Kathi Santora.)

H. Rap Brown

When a car traveling close to 55 miles per hour exploded near Tollgate Road and southbound Route 1 in the early morning of March 10, 1970, Bel Air instantly became the focus of America's ongoing civil rights movement. Police and locals rushed to the scene to find a somber stretch of car parts, body fragments, and smoldering fuel.

Though shocking, in retrospect, the calamity was not totally unforeseen. Later that day, H. Rap Brown, a controversial civil rights activist was scheduled to go on trial at the Bel Air Courthouse. In 1967, his fiery speech on the streets of Cambridge, Maryland, resulted in his arrest for inciting to riot and carrying a gun across state lines. Up to the moment of the blast, which could be felt more than a mile away from the Main Street courthouse, Bel Air had been tense, but quiet.

Two of Brown's associates, Ralph Featherstone and William Payne, occupied the car. At the time of the event, Brown's whereabouts were unknown.

To this day, opinions vary on the root of the incident. Some believe that Featherstone and Payne were on their way to bomb the Bel Air Courthouse and that the dynamite accidently exploded between Payne's legs. Some pointed to the possibility that white extremists had booby-trapped the vehicle. A few speculate that a nearby police officer inadvertently caused the blast when he keyed the microphone on his radio.

The trial never took place. Brown disappeared for the next 18 months. He was arrested after robbing a New York City bar. While in prison, Brown converted to Islam. Although he was an Atlanta grocery store owner and community activist who preached against drugs and gambling, he was again arrested in 2000 for murdering a police officer. He remains in prison in Colorado.

Meanwhile, there are locals who still recall the reverberation of a car bomb of unknown origin, the deathly smells, and the night that Bel Air became a storied part of the country's ongoing civil rights struggle.

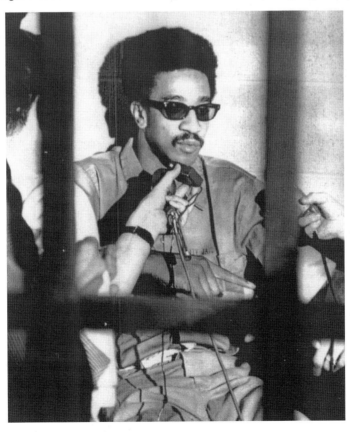

Grace Callwood

Grace Callwood met a lot of people during her treatment for a pediatric cancer from 2011 to 2014. There were, of course, a bevy of health professionals. However, it was the volunteers who came to cheer up sick children who left the biggest impression.

Even while still in treatment, Grace established a nonprofit organization called We Cancerve and assembled a board of directors composed entirely of school-aged students. Grace, who is now cancer-free, continues to grow her nonprofit with support from friends and fellow students. The mission and vision, set in place by its young members, is to support and bring happiness to homeless, sick, and foster children. Callwood, 11 years old, was named Harford County's Most Beautiful Person in 2015. (Kathi Santora.)

Margaret Webster Bissell

Everyone believed that the war would not last long, so when William Bissell left his pregnant wife, seven children, and a busy Main Street hotel to join the Confederate Army of Northern Virginia in 1861, he assumed he would be home for the birth of his child. Instead, two years later, after many battles, he was wounded in Pickett's Charge at Gettysburg on July 3, 1863. His wife received a note saying he was wounded but alright.

Margaret immediately called on family friends in the Union army to help her and her oldest daughter Mary journey to Gettysburg to nurse her husband. They traveled by stagecoach to Magnolia to board the train for Baltimore. After three days, they were able to gain permission to take the train to Gettysburg posing as members of the Christian Association who cared for the wounded. Three Bel Air physicians traveled with them and helped locate Captain Bissell. This was a monumental task as there were about 21,000 wounded soldiers housed in tents and in the fields. The captain had several seriously infected wounds. Margaret got permission to set up a tent for her family and care for her husband. She carefully dressed the wounds and made soup to help strengthen him but to no avail.

Doctor Richardson, a Union physician from Bel Air, amputated the infected leg, but could not save Bissell. Soon after his death, Margaret and her daughter returned to Bel Air, eventually bringing Captain Bissell's body home for burial. Margaret went on to manage the hotel and raise her children on her own. She died in 1906 at the age of 89.

INDEX

LEGENDARY
LOCALS

AN IMPRINT OF ARCADIA PUBLISHING

Find more books like this at
www.legendarylocals.com

Discover more local and regional history books at
www.arcadiapublishing.com

Consistent with our mission to preserve history on a local level, this book was printed in South Carolina on American-made paper and manufactured entirely in the United States. Products carrying the accredited Forest Stewardship Council (FSC) label are printed on 100 percent FSC-certified paper.

MADE IN THE
USA